Photography by
Ben Hansen

Foreword by
Dr. Leslie Harris

Captions by Derek Yetman
Graphic Design by Stewart Moss

Vinland Press St. John's NF

NEWFOUNDLAND AND LABRADOR

Dedicated to our grandchildren:
Carl, Robert, Alice, Eric, Lydia, Nicholas,
Emily, David, Joel, Levi, Rachel, Tara and Isaac

Special thank you to Marine Atlantic and
Department of Tourism and Culture for travel assistance

Foreword

IN HIS EXCELLENT BOOK *The Rock Observed*, Patrick O'Flaherty draws our attention to the vocabulary and the imagery used by W. E. Cormack to describe the Newfoundland he saw in the course of his walk across the island. As he sets out, he uses words that convey the "inexpressible delight" with which he observes vistas that "break in sublimity" before him. Towards the end, such descriptive adjectives as dreary, coarse, bald, monotonous, reflect the "bludgeoned sensibilities" of one who has endured 50 days of unremitting toil and who has, indeed, been in peril of death from exhaustion, hypothermia, starvation, or from a combination of all three. This illustrates the point that the eye is not simply a mechanical device that registers candidly what is platonically there, but rather is a complex picture maker that is informed by one's frame of mind and by one's peculiar sensibilities. And when we look at photographs, we look not only through the filters of our own frame of mind and our own sensibilities, but, as well, through the eye of the artist who held the camera and who made the picture that we have before us.

The pictures in this book were all made by Ben Hansen. They are the latest of his photographic interpretations of Newfoundland and Labrador. To comment upon the professional quality of the photographs would be redundant since prize winning professionalism is explicit in everything that Ben Hansen does. What is more to the point is our appreciation of the ways in which the pictures go beyond mere competence to become works of art that invite us to see through the creative eye to the sensibilities that gave them shape: to see the Newfoundland that is in Ben Hansen's mind.

As we look, we see that very few of his compositions are of nature unaffected by the human presence. There are a few exceptions, but in almost all cases the land and sea scapes provide the frames of reference or the spectacular backdrops for clusters of houses, stages, stores, wharves and slips, fences and clotheslines, dories and punts and komatiks, and all the other built elements of a Newfoundland community. And in presenting those images of human adaptation to a particular environment, what does the artist say of the community that emerges? Certainly, the images are not those of a hard life on sea scoured, storm ravaged, rock bound coasts, nor of a fatalistic tenacity with grim survival as its goal. Rather, we see in those marvellous photographs, in the bright colours, the cheerfully jumbled disposition of buildings, in the jauntily saucy buoyancy of the boats in their safe anchorages and sheltered coves, in the calm seas and everlasting hills, in the brilliant sunshine, in the gentle softness of the occasional fogs, havens of security, of peace, of good living, of sustenance for body and for spirit. But these are not just pretty pictures, composed to gratify the local Chamber of Commerce. Rather, they are created to express a love for, and a belief in, a life style as uniquely satisfying in a psychological way as the landscapes are satisfying in their aesthetic dimensions.

Is Ben Hansen's view a romantic one? We cannot deny it. But let us remember what Turner said to the prosy critic who scorned one of his paintings because no one had ever seen such brilliant colours in a sunset. "But don't you wish that you had?" So it is with this vision of Newfoundland and Labrador. At a time when so much is threatened with dissolution, don't we just wish. . . . In any case who can resist so much bright beauty, such clear definition, such clarity and simplicity, such artful primitiveness as takes us directly to conception of "another eden, demi-paradise."

Leslie Harris

Outer cove ❧
Avalon Peninsula

NEWFOUNDLAND

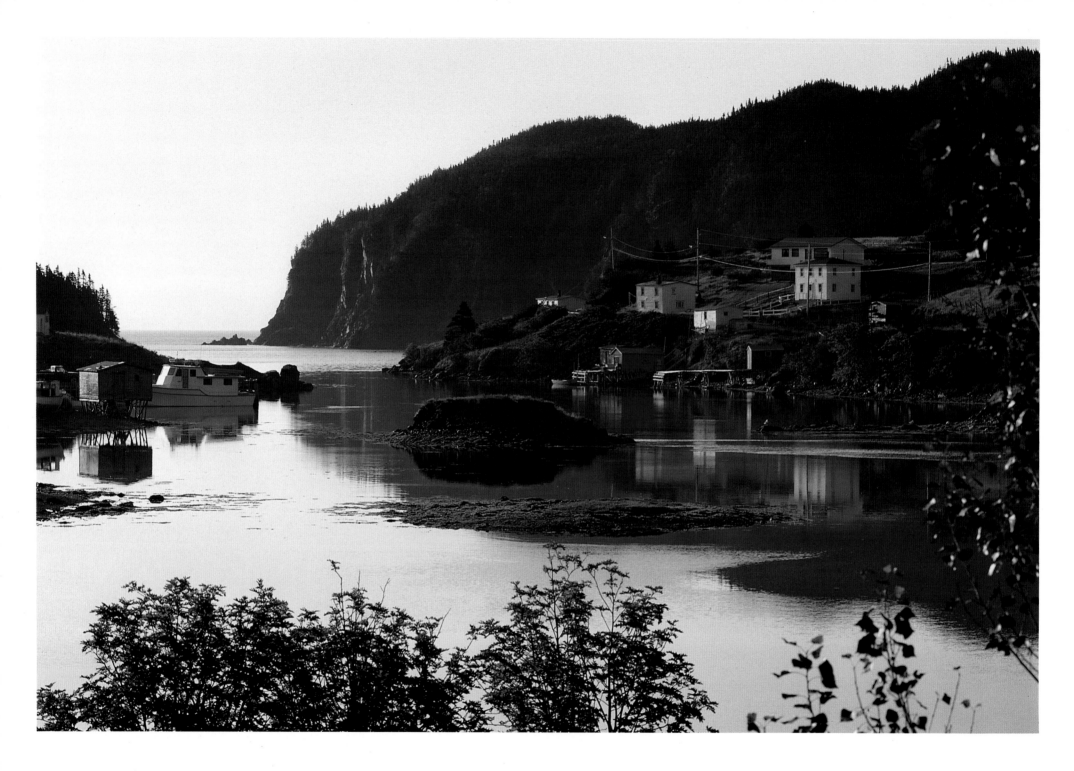

The community of Mortier, on the Burin Peninsula, awakens to a promising day...

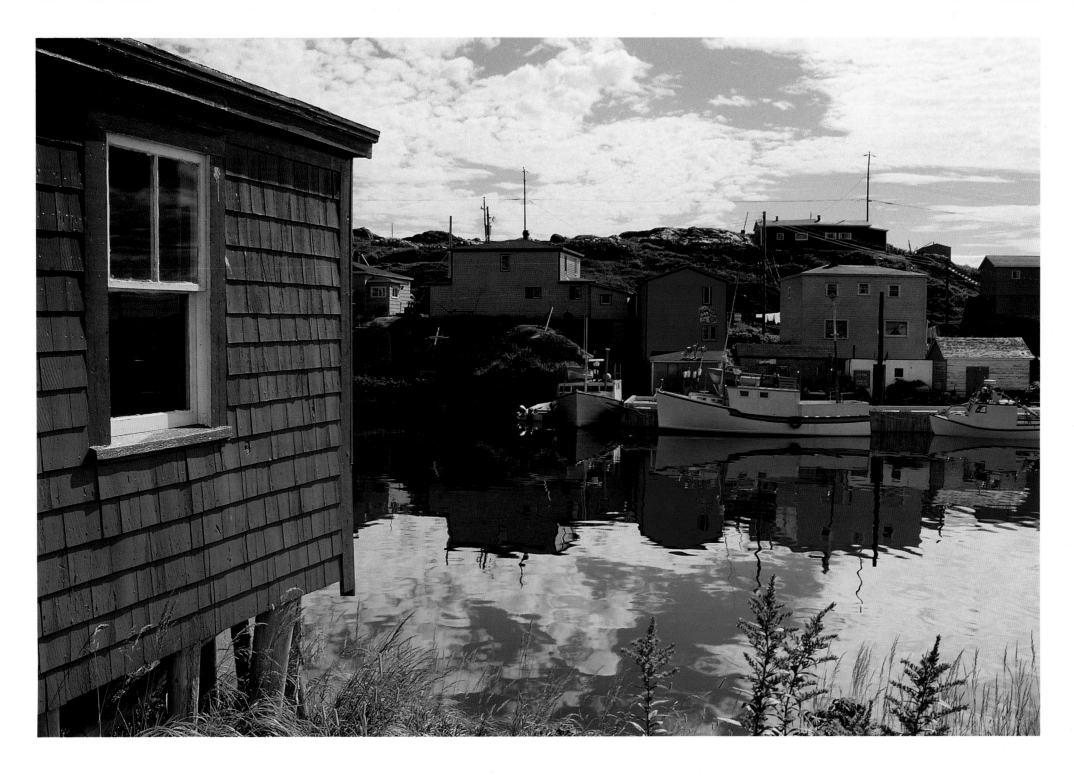

. . .as does the town of Rose Blanche, on the province's southwest coast.

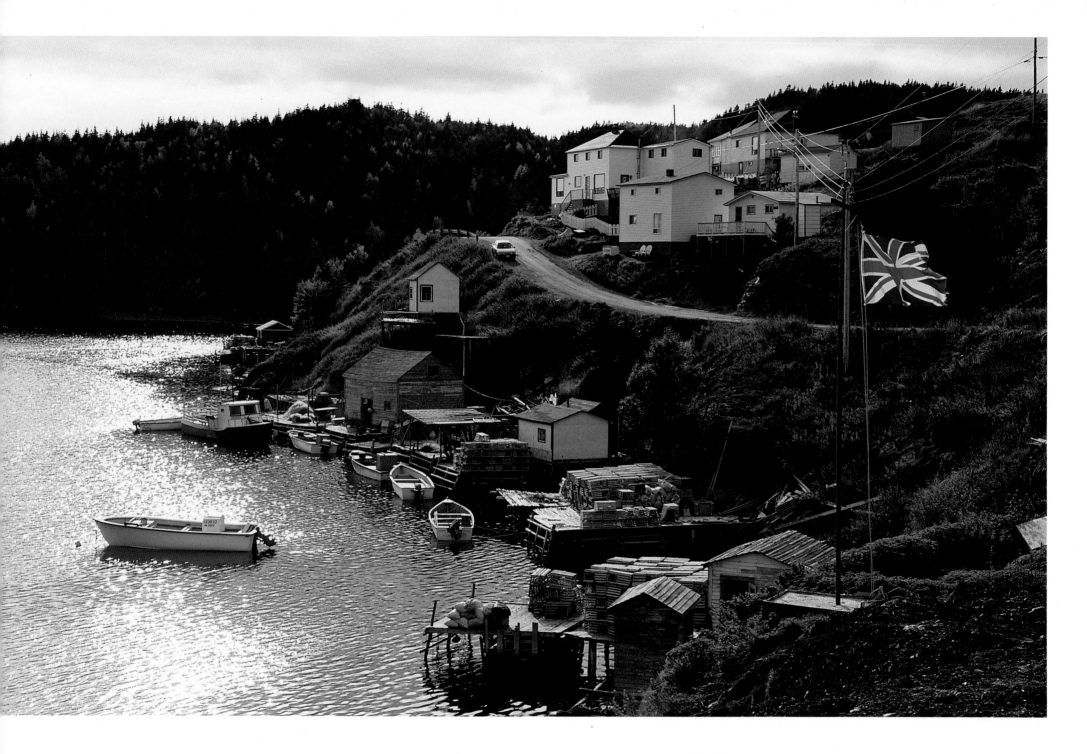

At the fishing stages in Bridgeport, Notre Dame Bay, little appears to have changed since the days before Confederation.

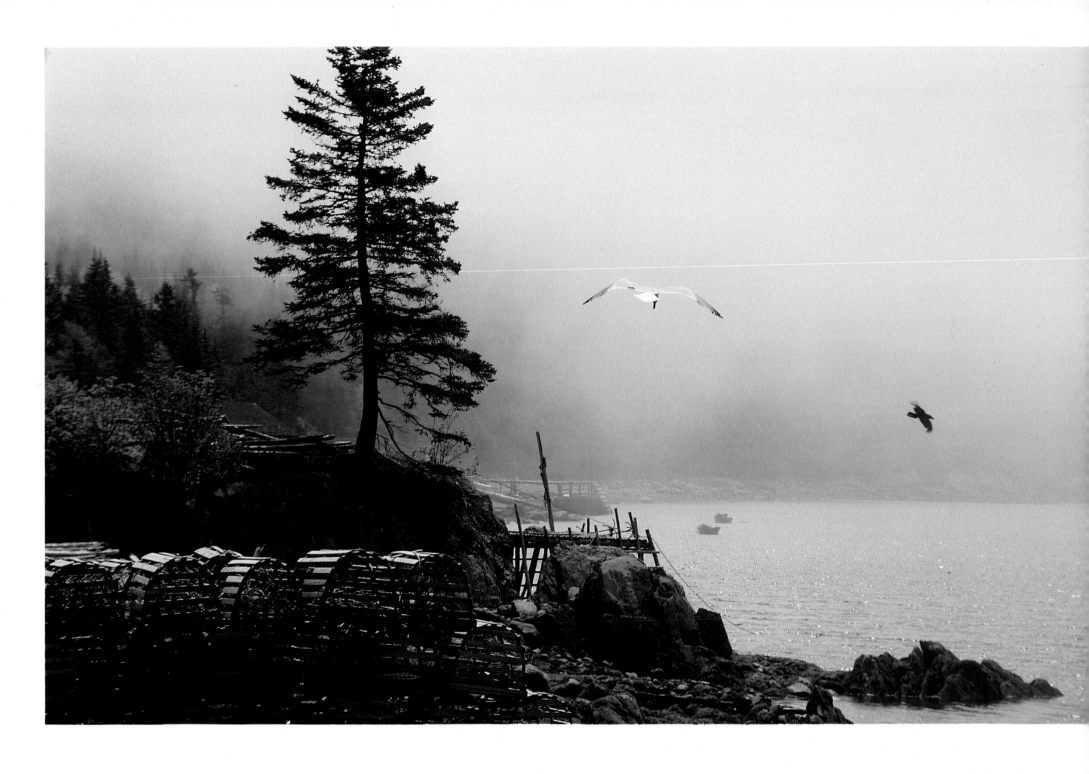

Lobster pots stacked and ready for the season in Garden Cove, Placentia Bay.

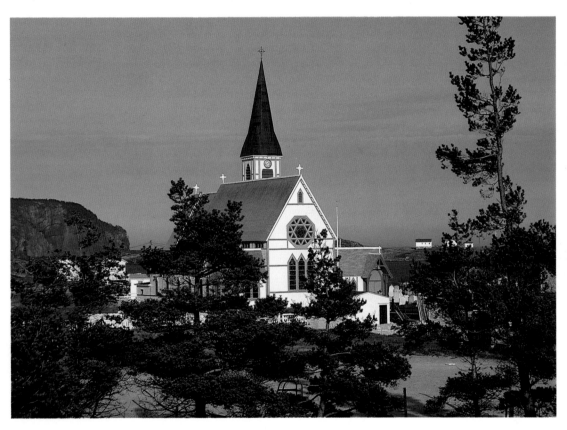

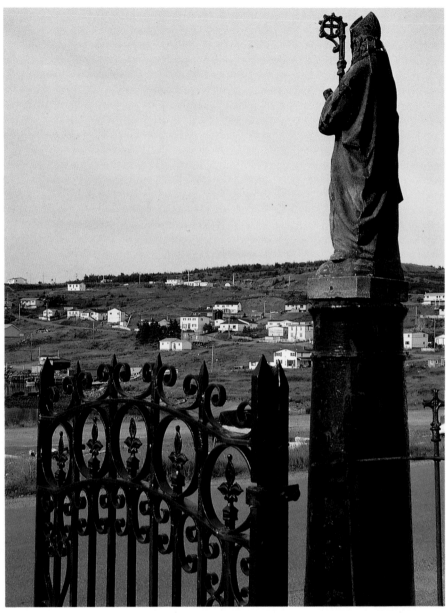

St. Paul's Anglican Church in Trinity—
one of the oldest churches in the province.

In historic Bay Bulls, a ship's cannon serves
as a pedestal for an ecclesiastical statue.

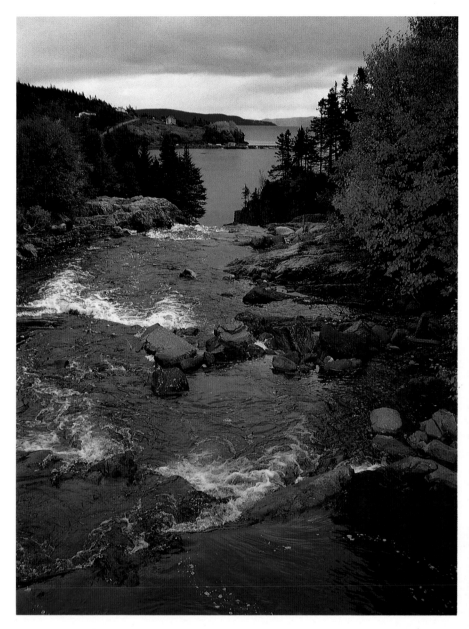

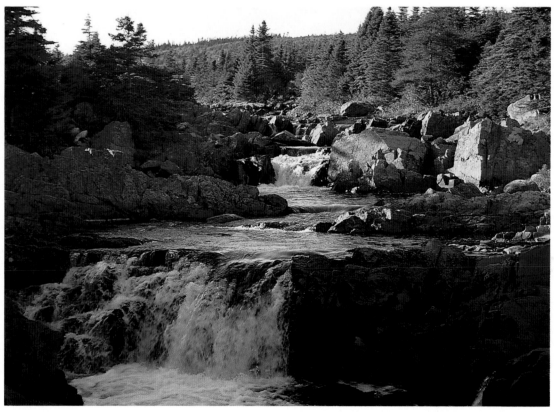

Deep Bight River rushes to join the sea in Northwest Arm, Trinity Bay.

A brook meanders through the countryside near Northern Bay Sands, Conception Bay.

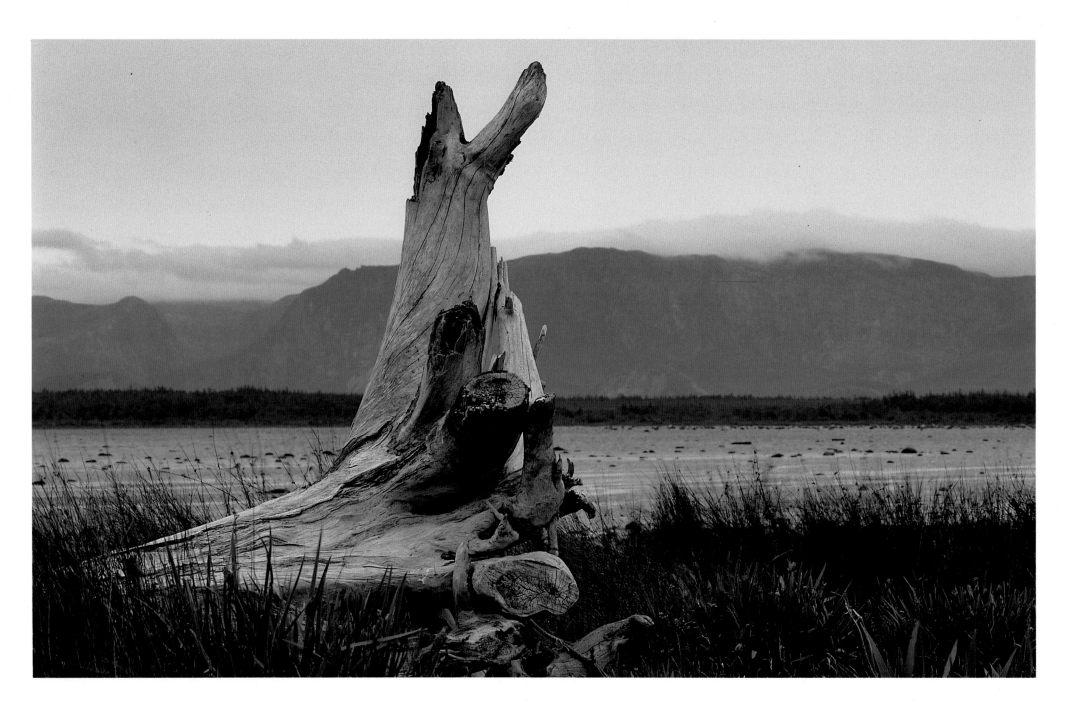

Nature works its sculpture in wood at Parsons Pond on the Northern Peninsula . . .

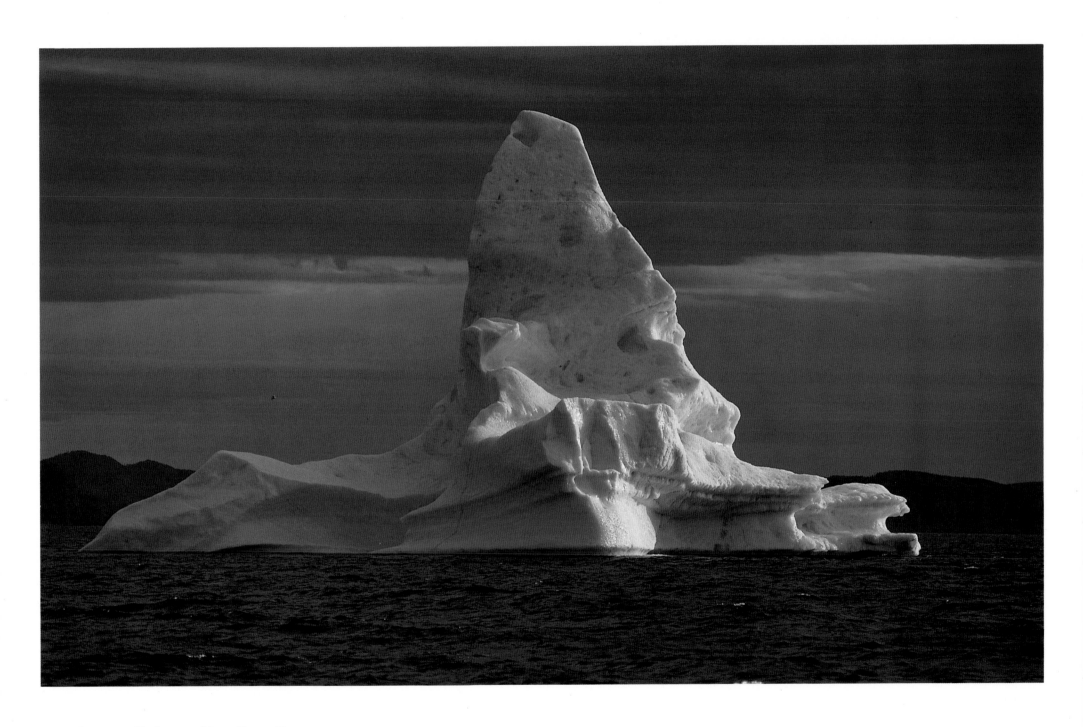

. . .and in ice at Twillingate, Notre Dame Bay.

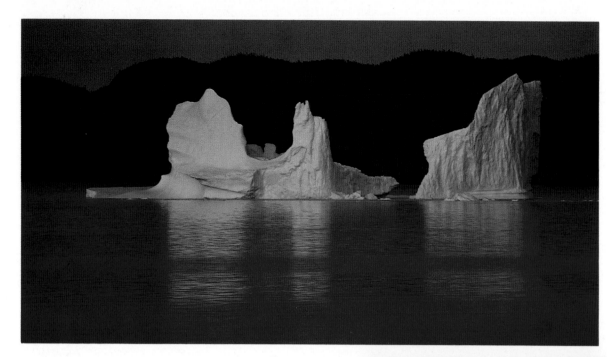

Ghostly figures rise out of the ocean near Lewisporte, Notre Dame Bay.

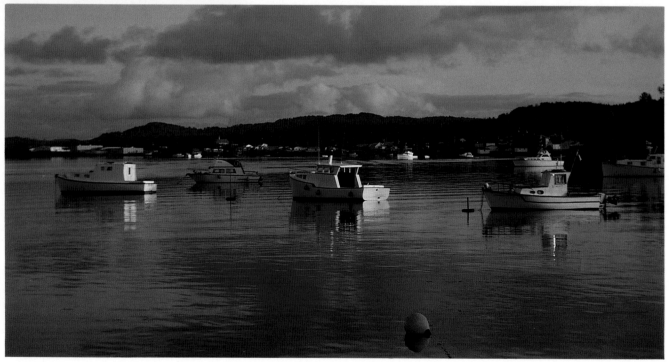

Pleasure boats lie moored at the Yacht Club in Lewisporte.

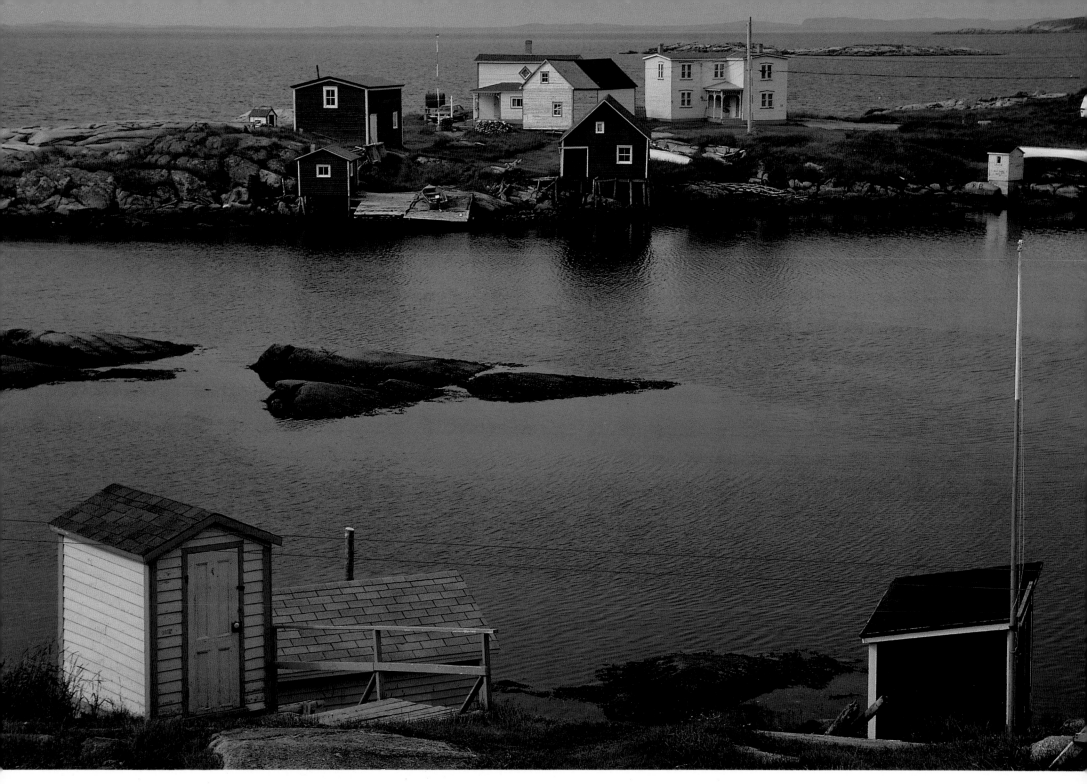

"*The Point*" on the island of Greenspond, Bonavista Bay.

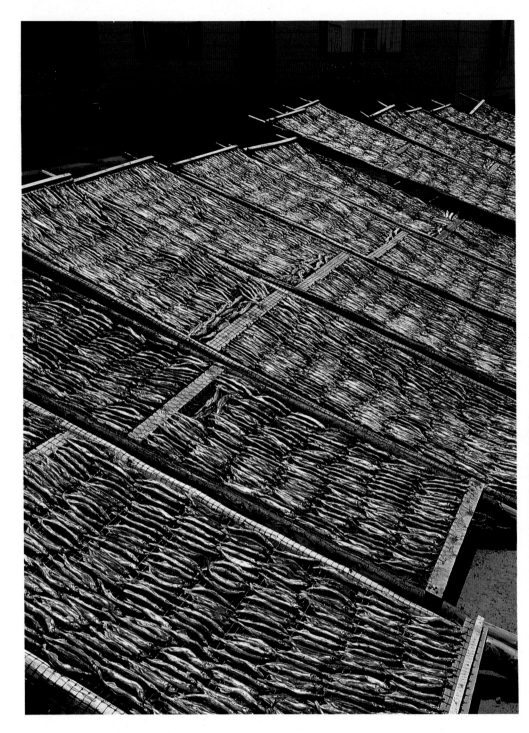

*"...their greatest delicacy in the Fish way is a
small Fish called here caplin..."*

–Sir Joseph Banks, 1766

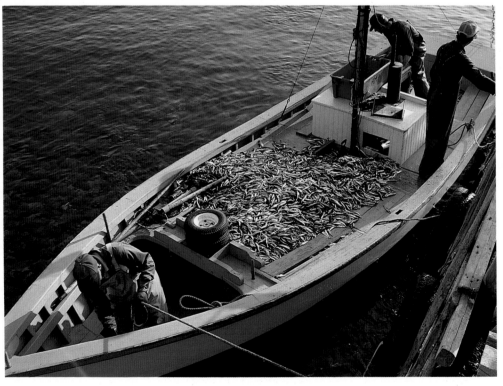

A trap skiff loaded with caplin, the silver of the sea,
ties up at a wharf in Little Harbour, Notre Dame Bay.

12

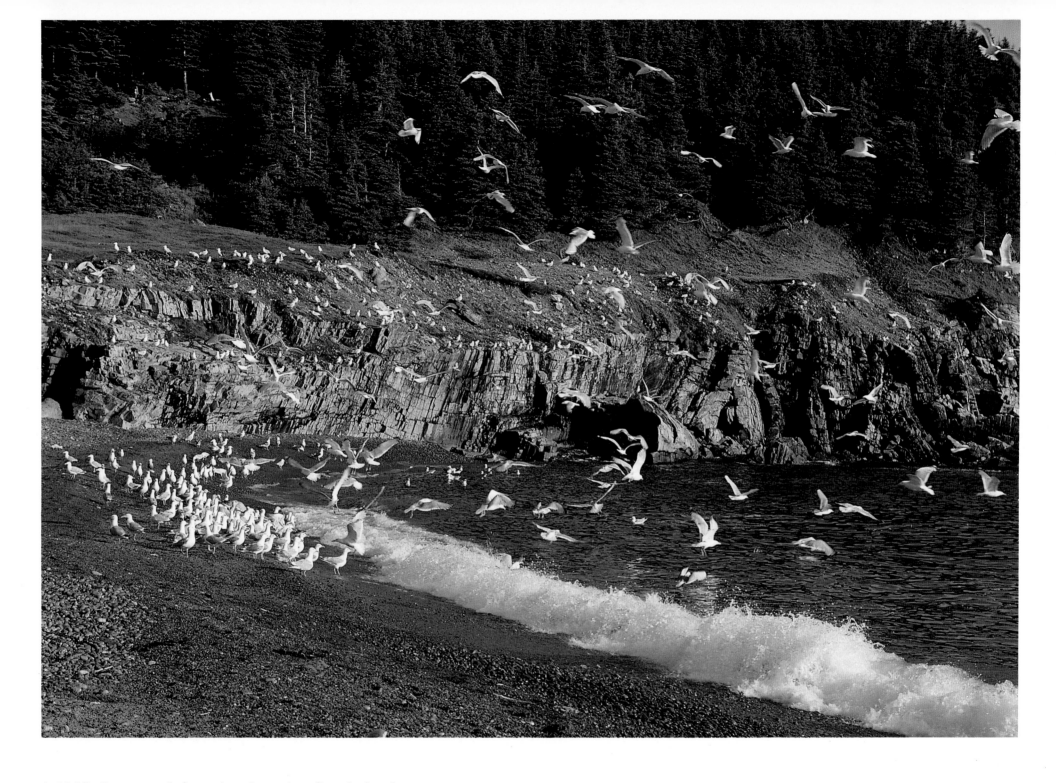

At Middle Cove, seagulls feast when the caplin roll on the beach to spawn.

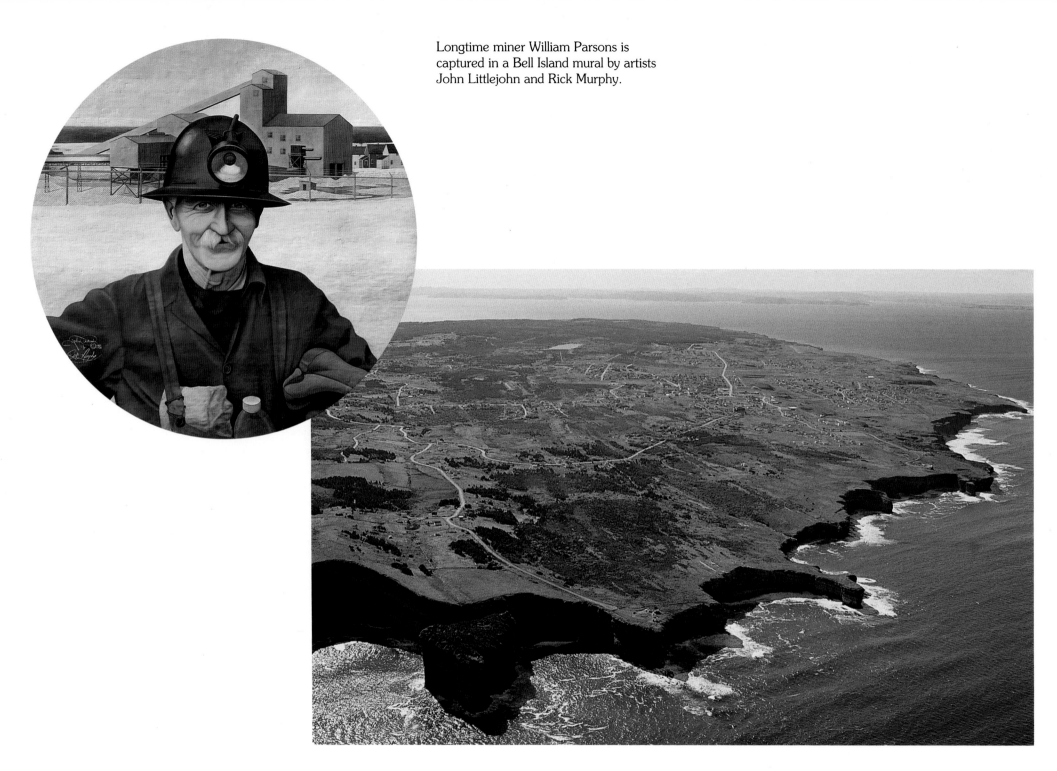

Longtime miner William Parsons is captured in a Bell Island mural by artists John Littlejohn and Rick Murphy.

Bell Island from the air, showing some of the fields that were first cultivated in the 17th century.

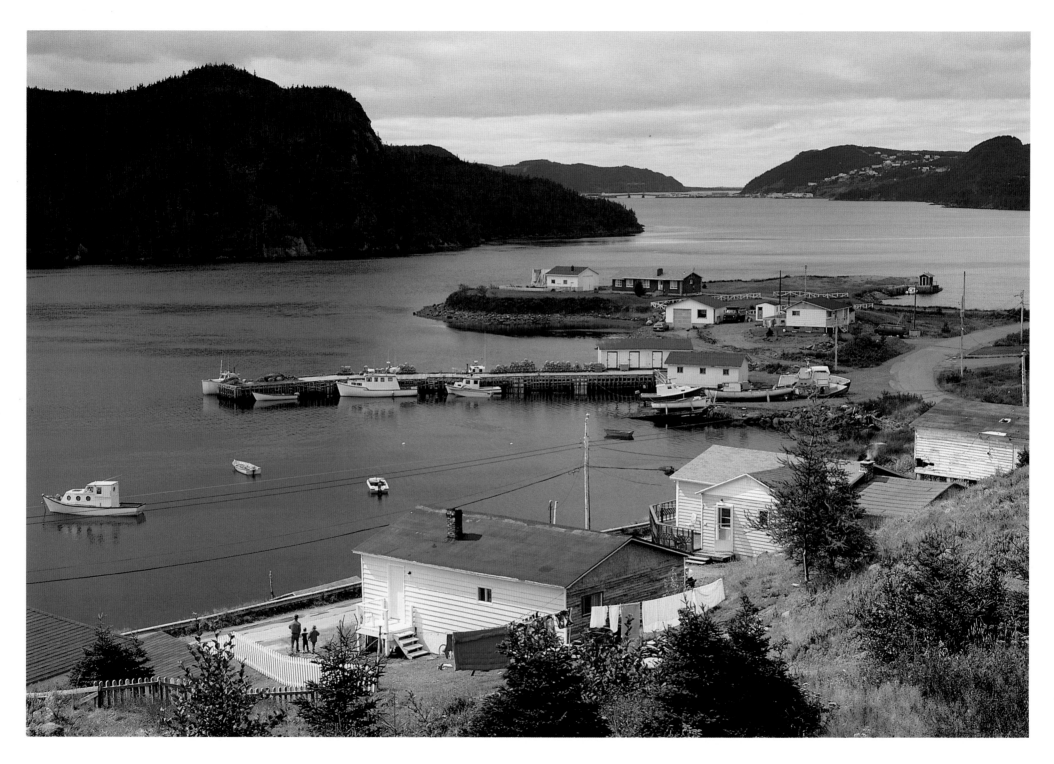

Sentinels of stone protect Dunville from the rougher waters of Placentia Bay.

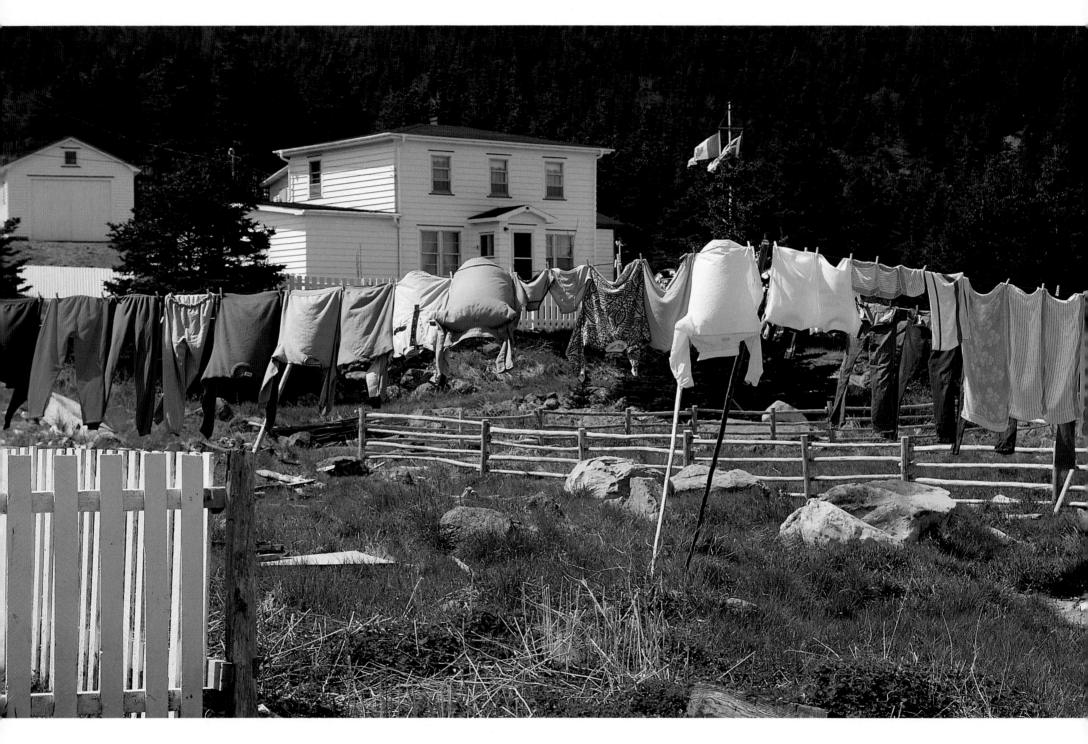

Sunshine and a breeze—the perfect day for drying clothes in Fox Harbour. . .

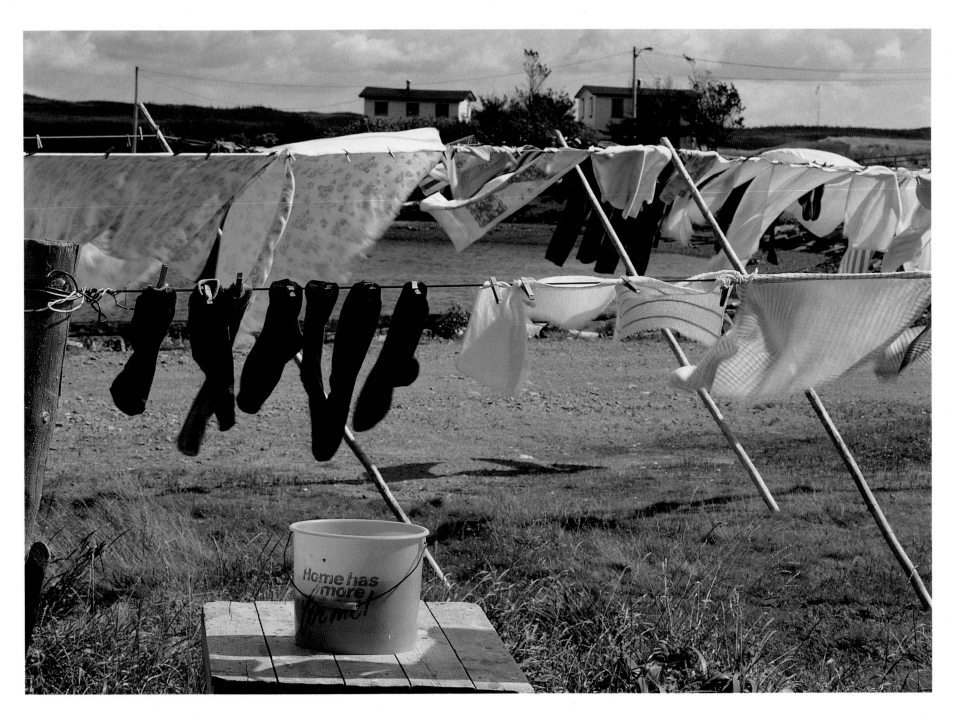

. . .or North Harbour, or anywhere else.

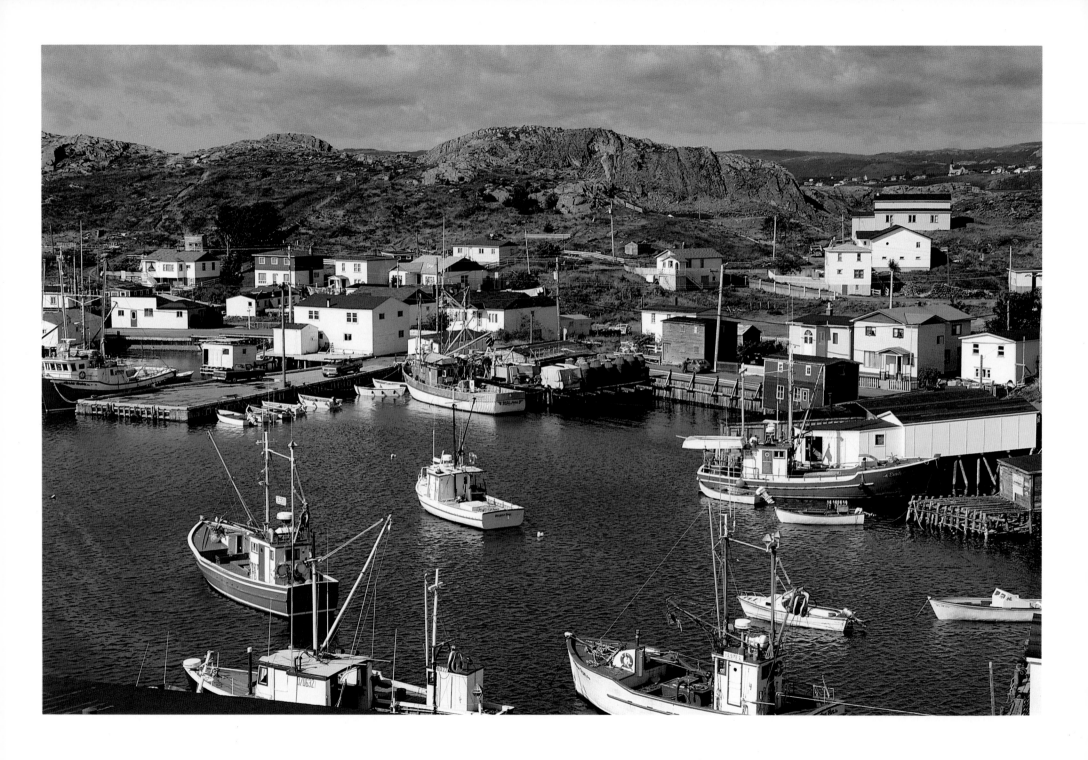

The busy fishing town of Port de Grave, whose name reflects a time when men of many nations fished in Conception Bay.

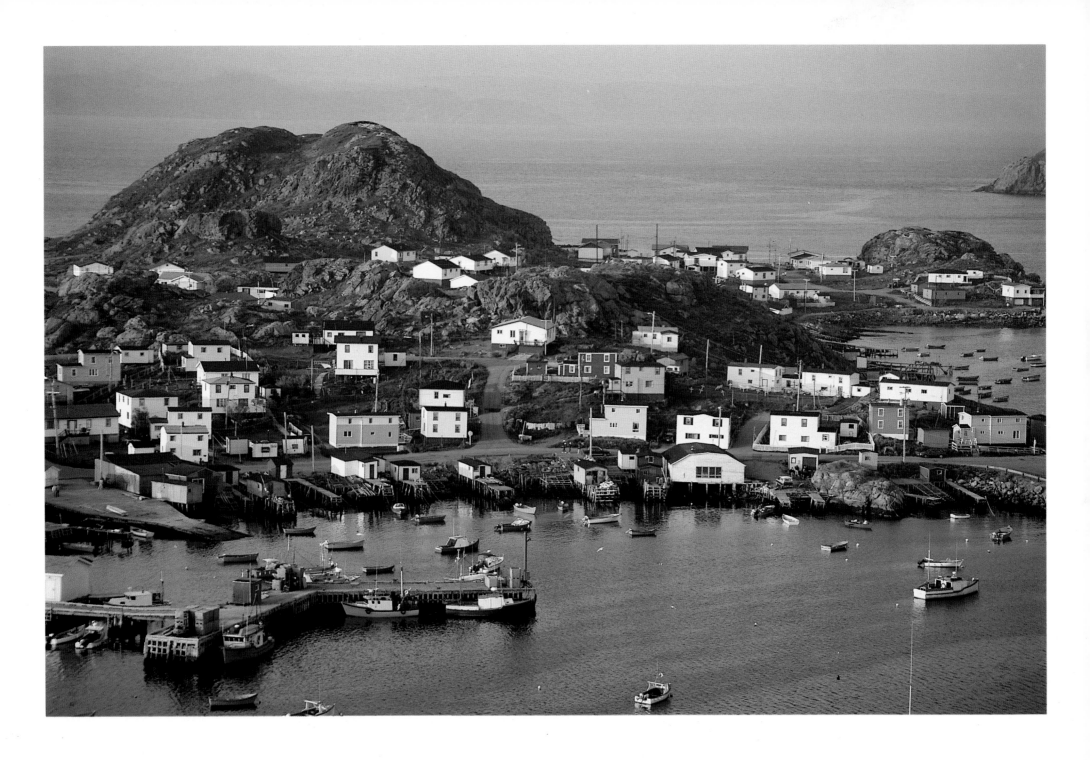

The community of Ramea is believed to have derived its name from the French "rameaux",
meaning branches—possibly a reference to the many small islands nearby.

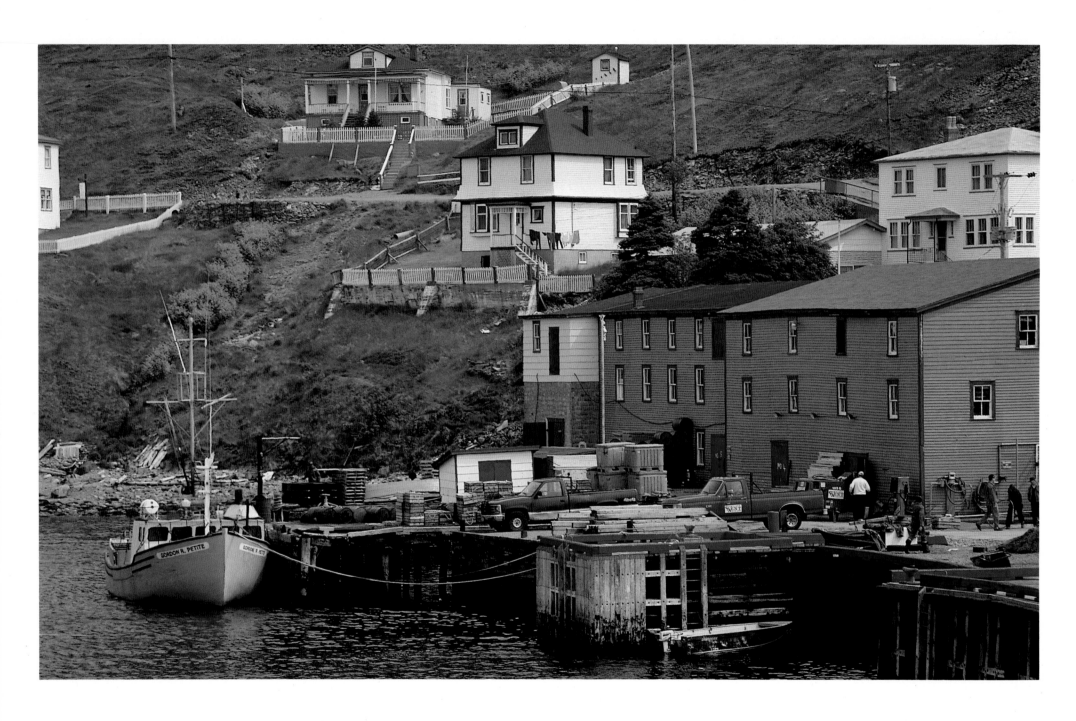

There seems to be little doubt as to who settled English Harbour West in Fortune Bay.

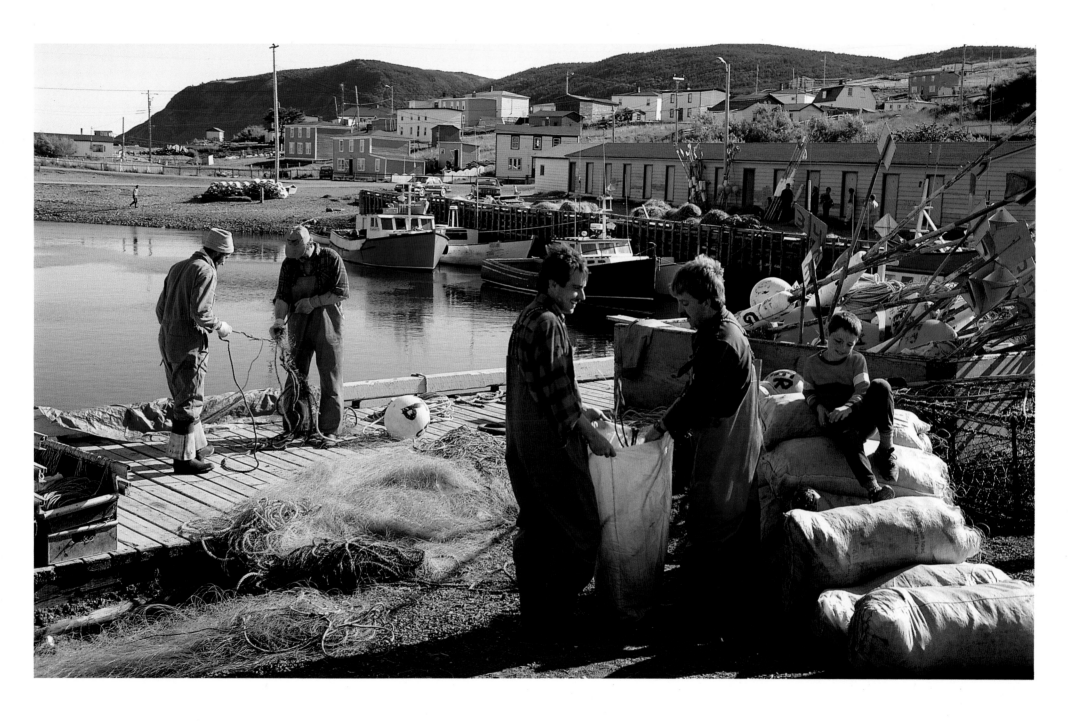

Branch, in St. Mary's Bay, has a strong Irish heritage that is still evident in speech and tradition.

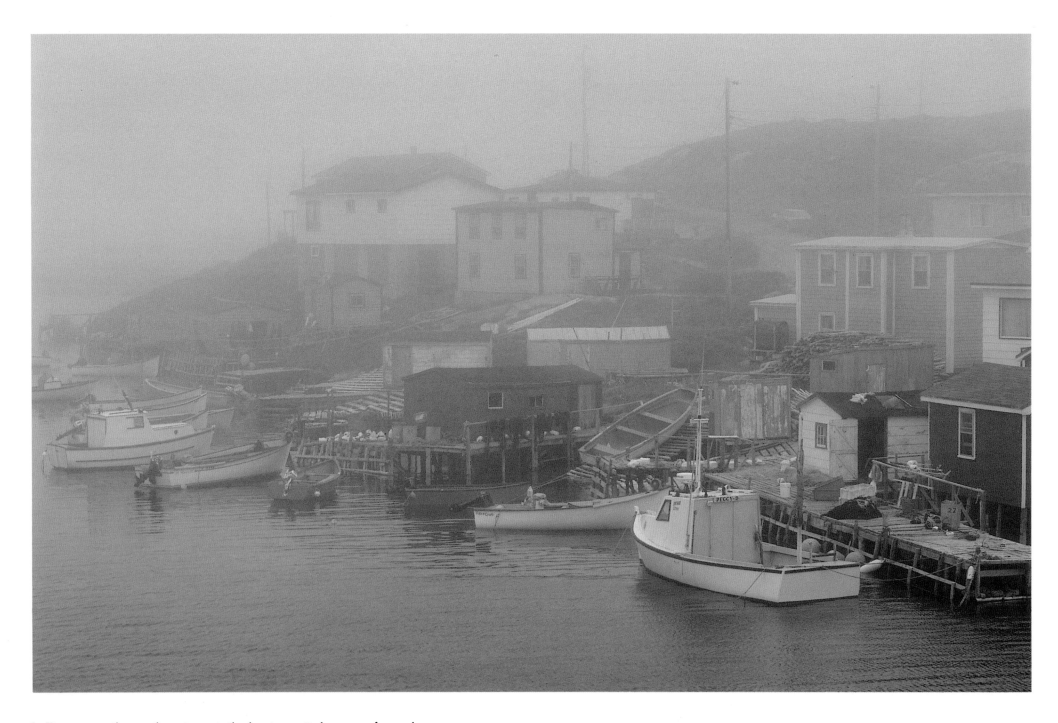

In Burgeo, on the southwest coast, the boats are tied up on a foggy day. . .

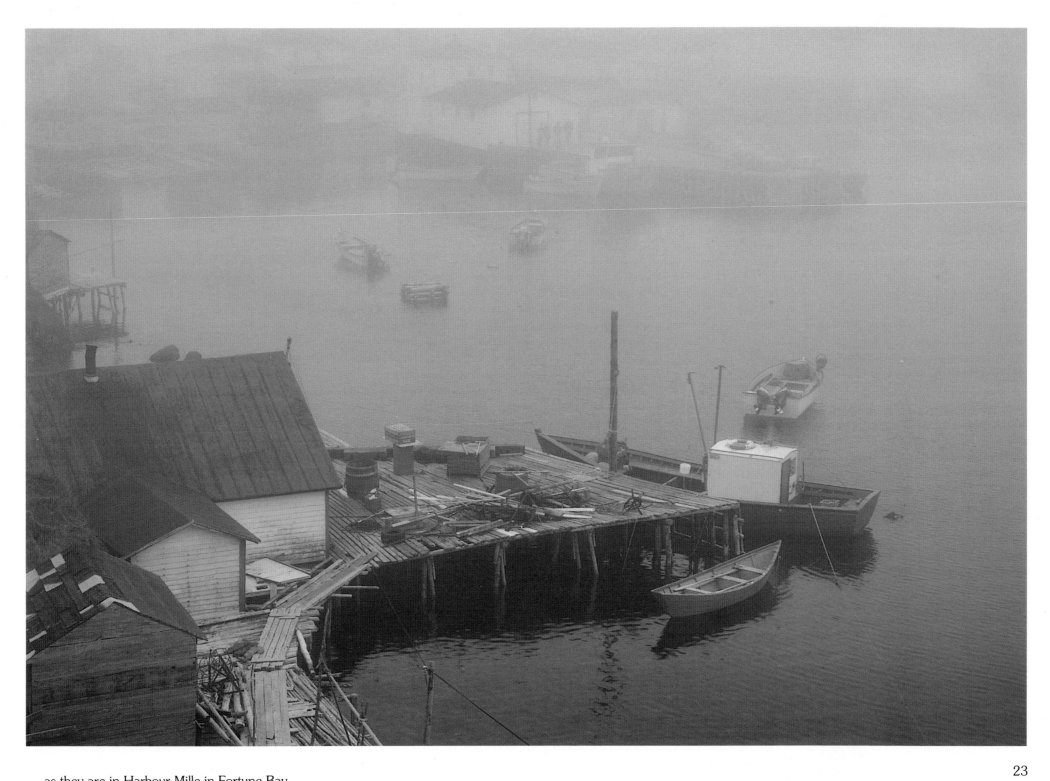

. . .as they are in Harbour Mille in Fortune Bay.

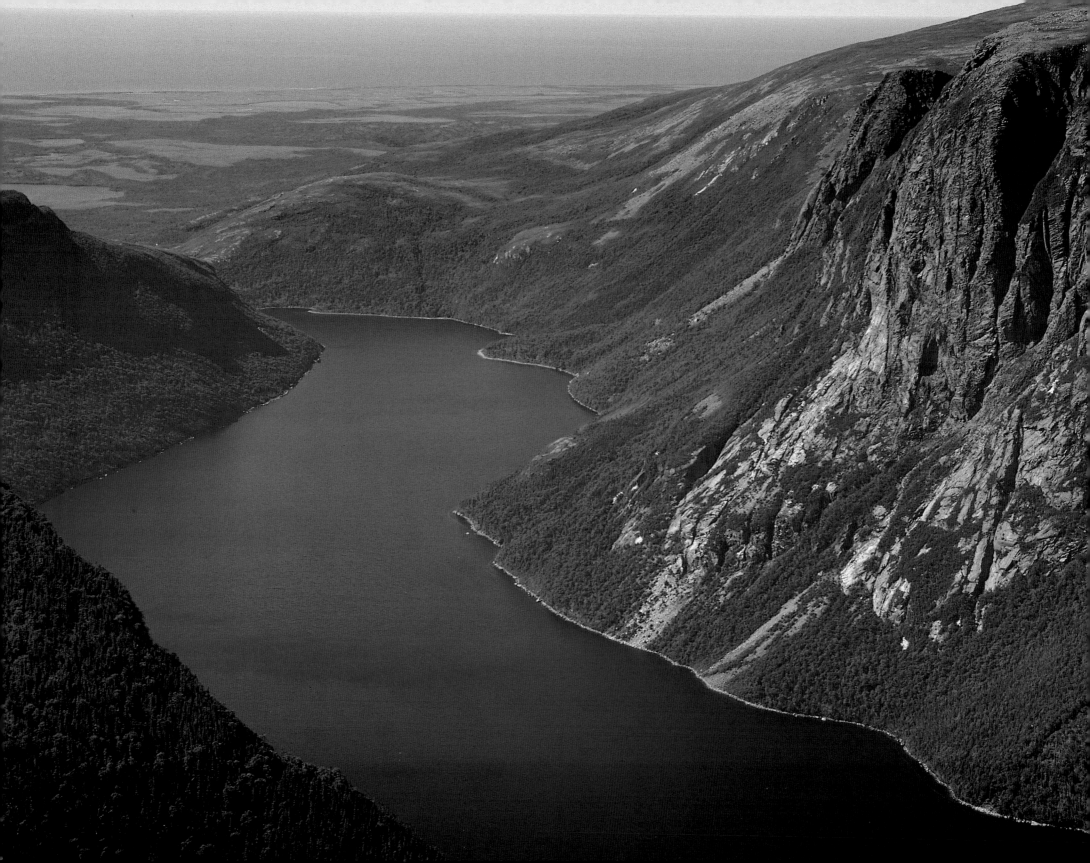

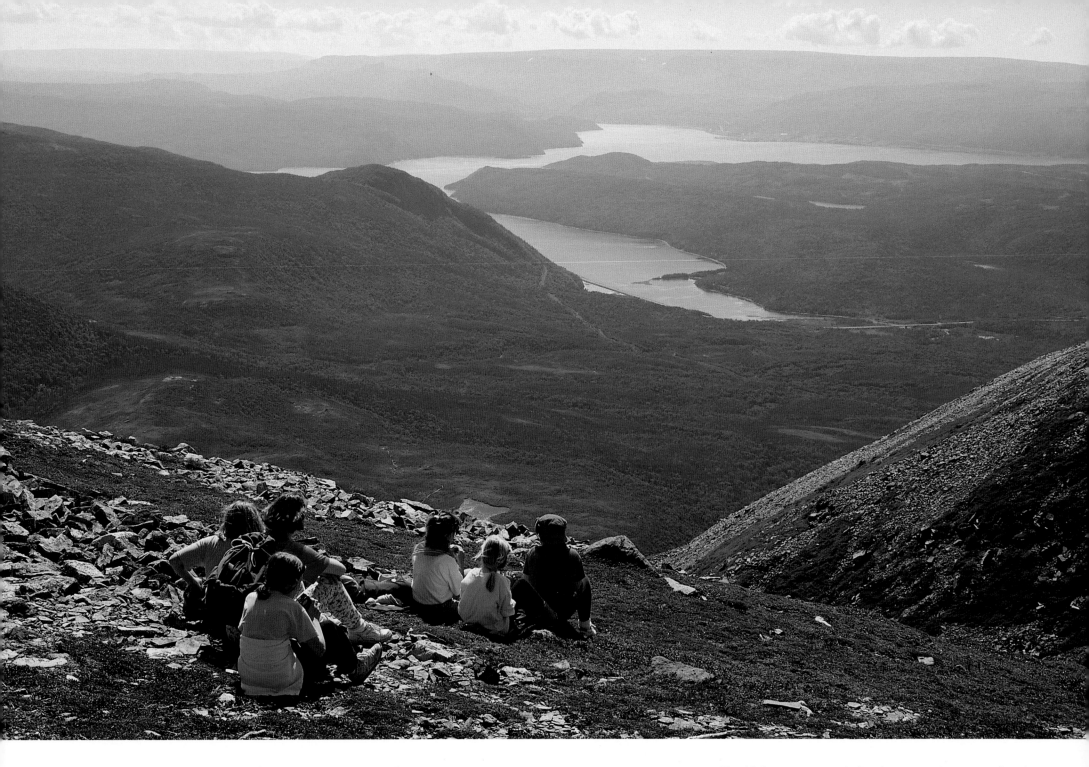

◄● A magnificent view of Ten Mile Pond from atop Gros Morne, the mountain from which the west coast park takes its name.

Tired hikers are rewarded with spectacular vistas after their hike up the 800 metre high mountain.

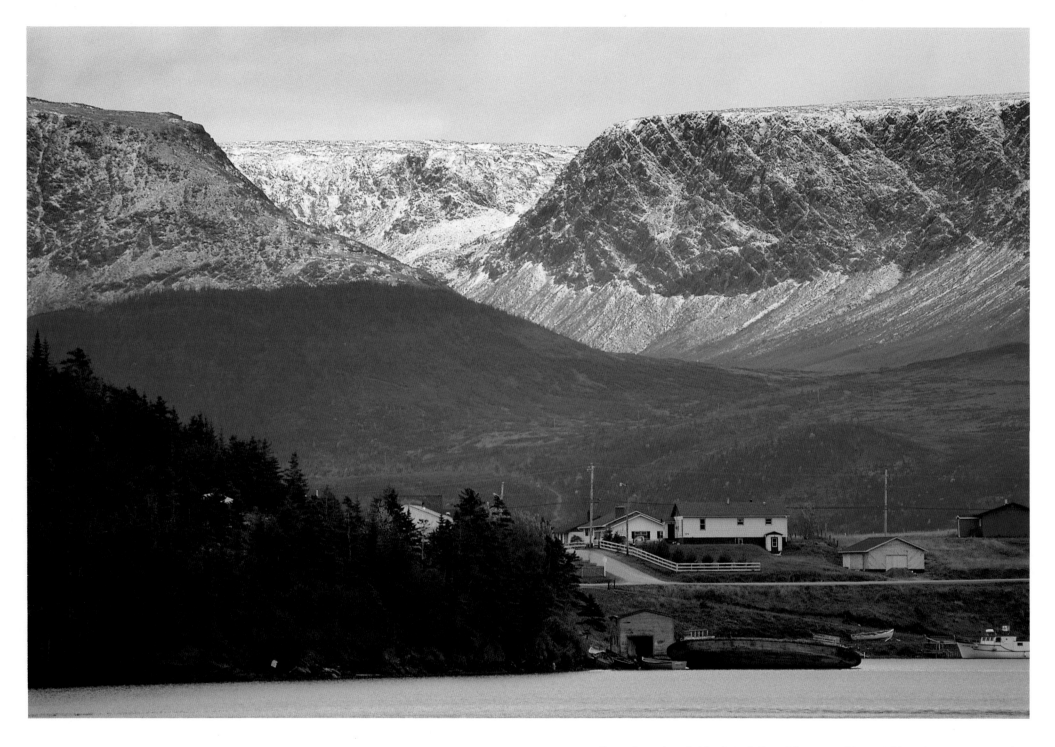

Snow has already blanketed Gros Morne and its neighbouring mountains, but
Norris Point and Woody Point enjoy another day before the onset of winter.

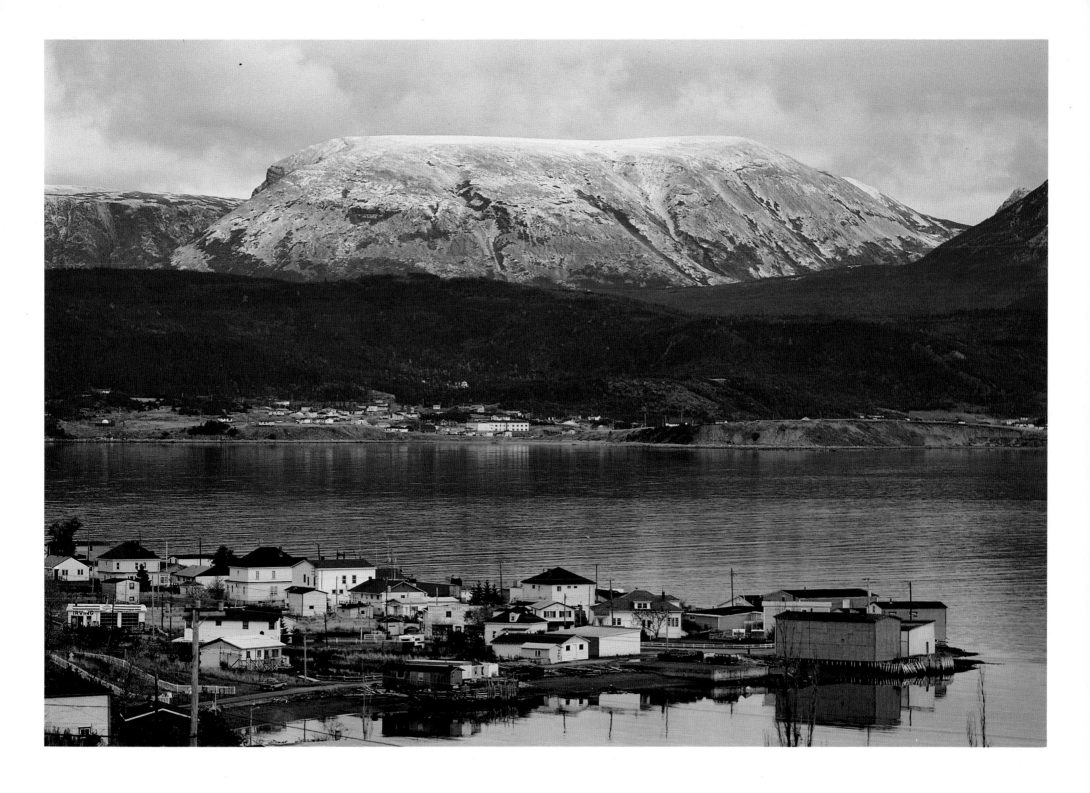

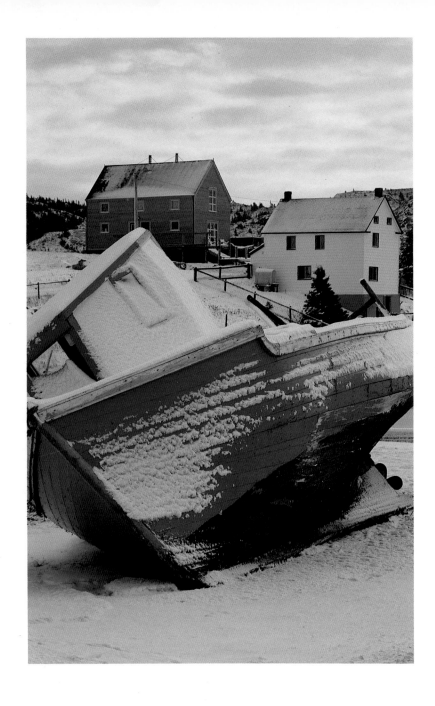

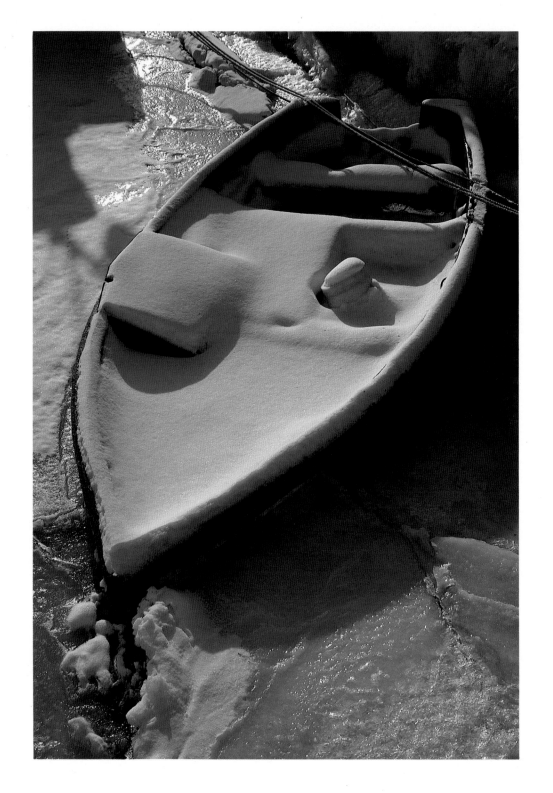

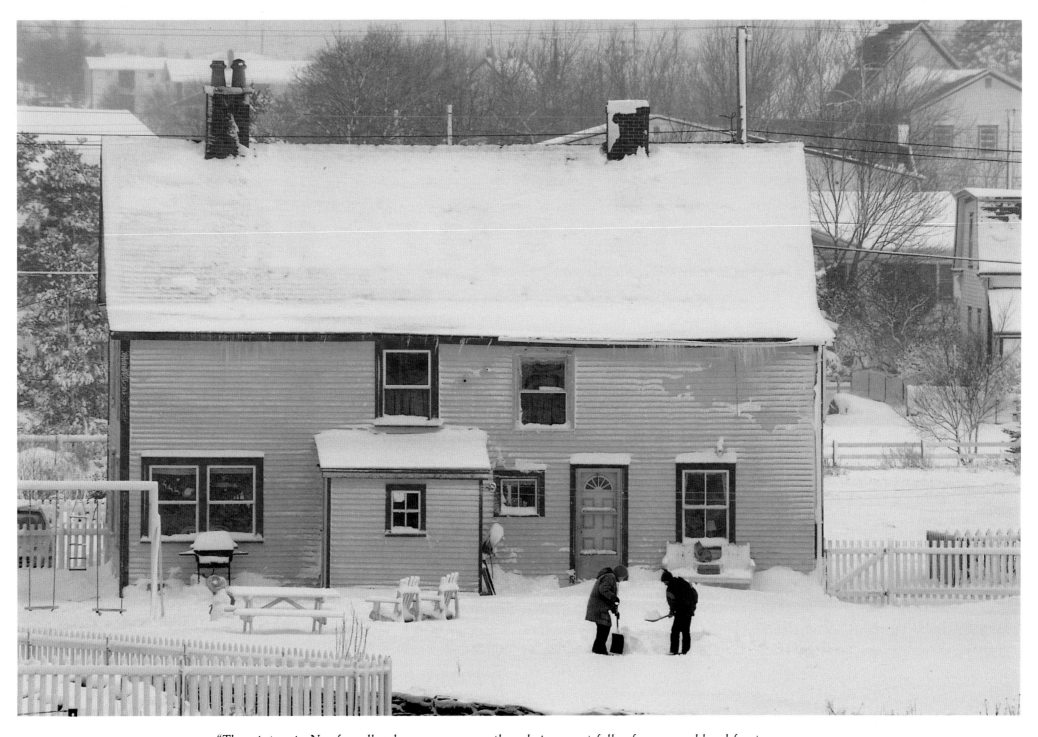

"*The winters in Newfoundland are very severe, there being great falls of snow, and hard frost. . . my shoes have been so hard frozen that I could not well put them on, till brought to the fire. . .*"
– Lawrence Coughlan, 1776

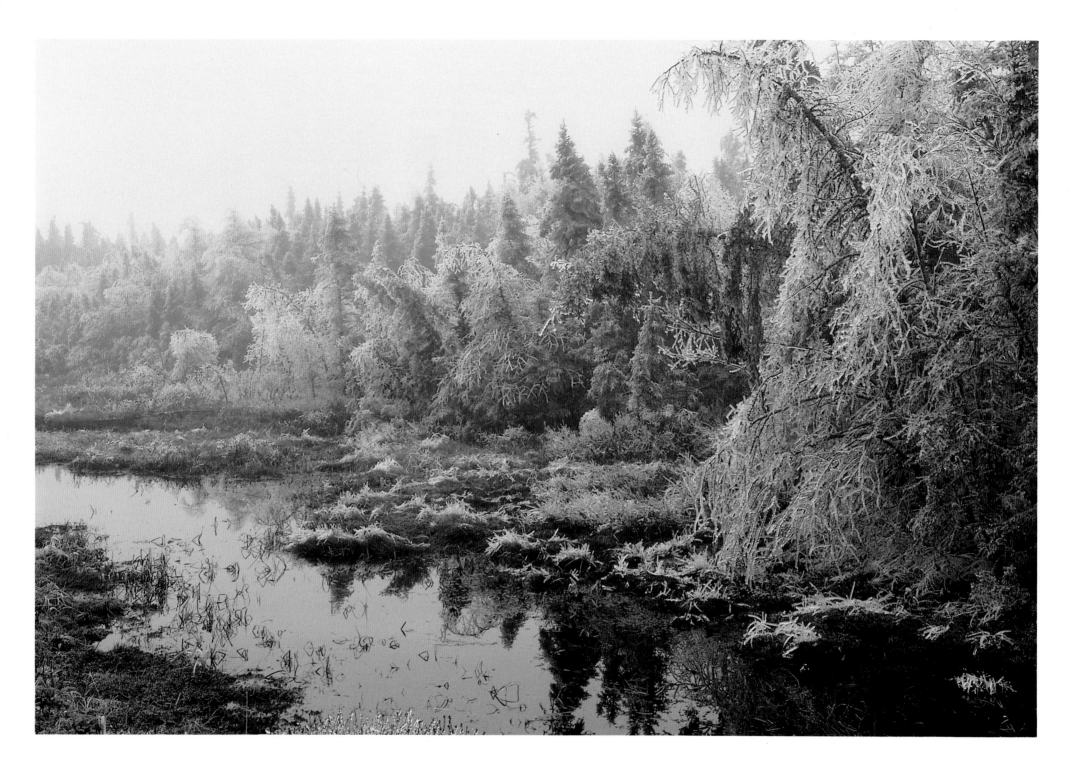

A silver thaw transforms the landscape after a fall of freezing rain.

A growler in the harbour at Winterton provides a convenient gathering place for seagulls.

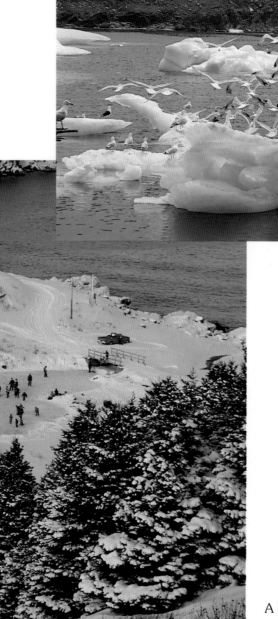

A hockey game in progress on a frozen pond in Torbay.

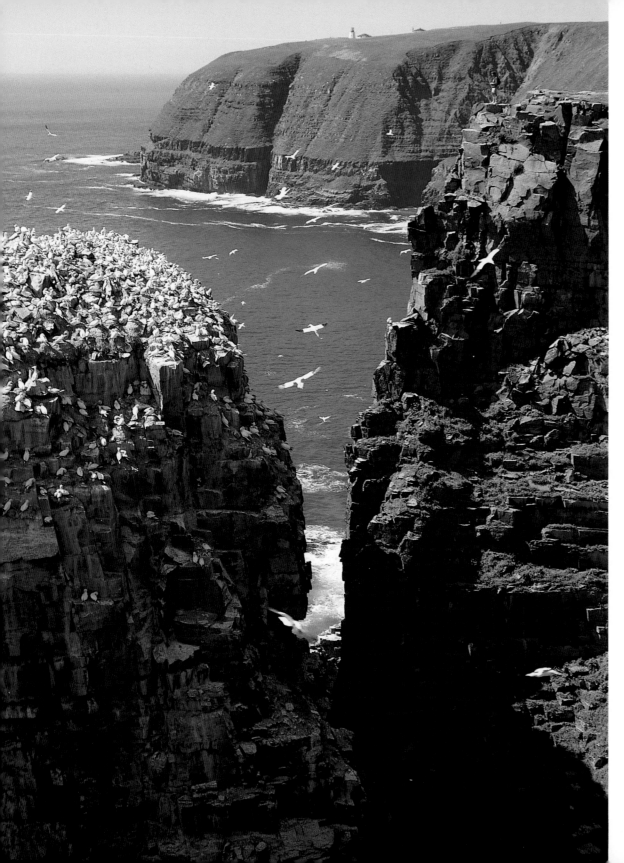

Bird Rock, at Cape St. Mary's Ecological Reserve, is the second largest nesting site for gannets in North America.

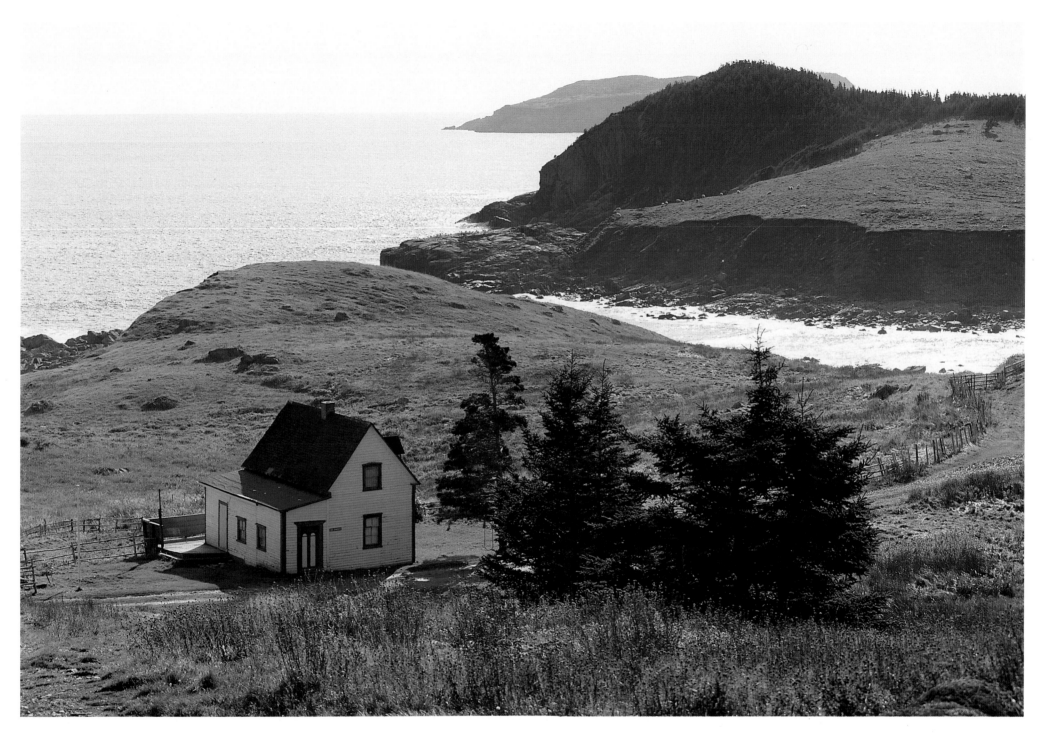

"*The Cribbies*" at Tors Cove. The name comes from a nativity
scene that was a tradition at the house during christmas.

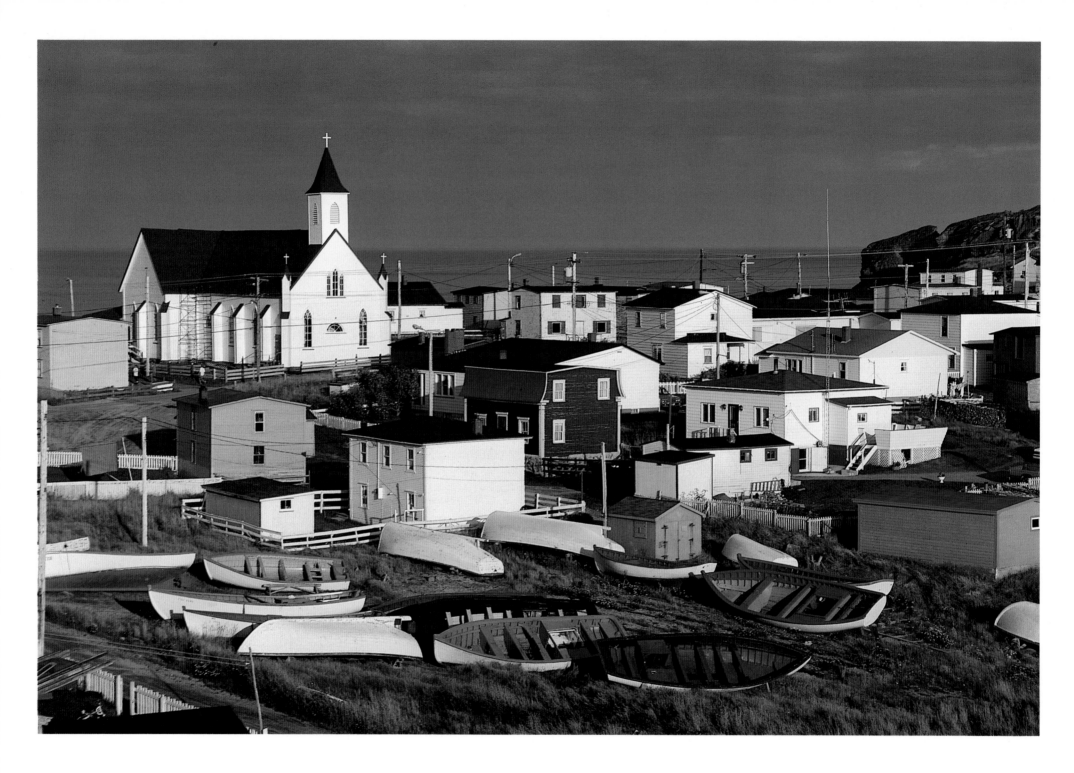

Beautiful Bay de Verde, which despite its name was settled by English colonists in the 1600's.

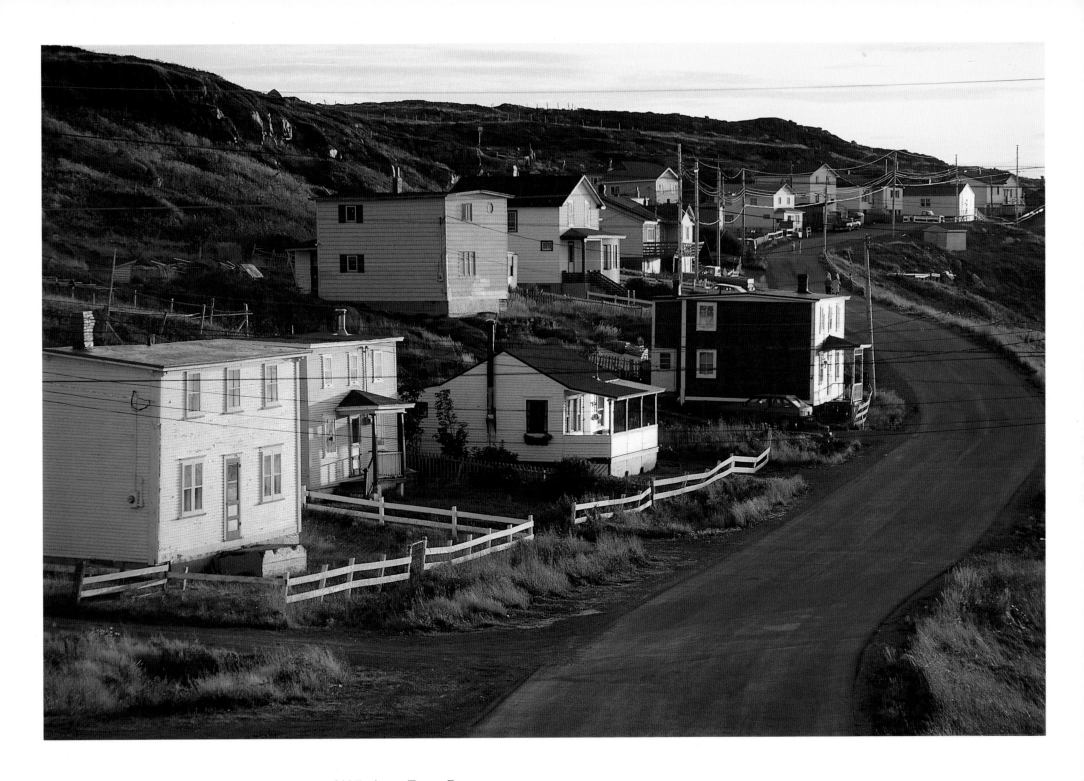

The evening sun reflects off the roadside houses in Old Perlican, Trinity Bay.

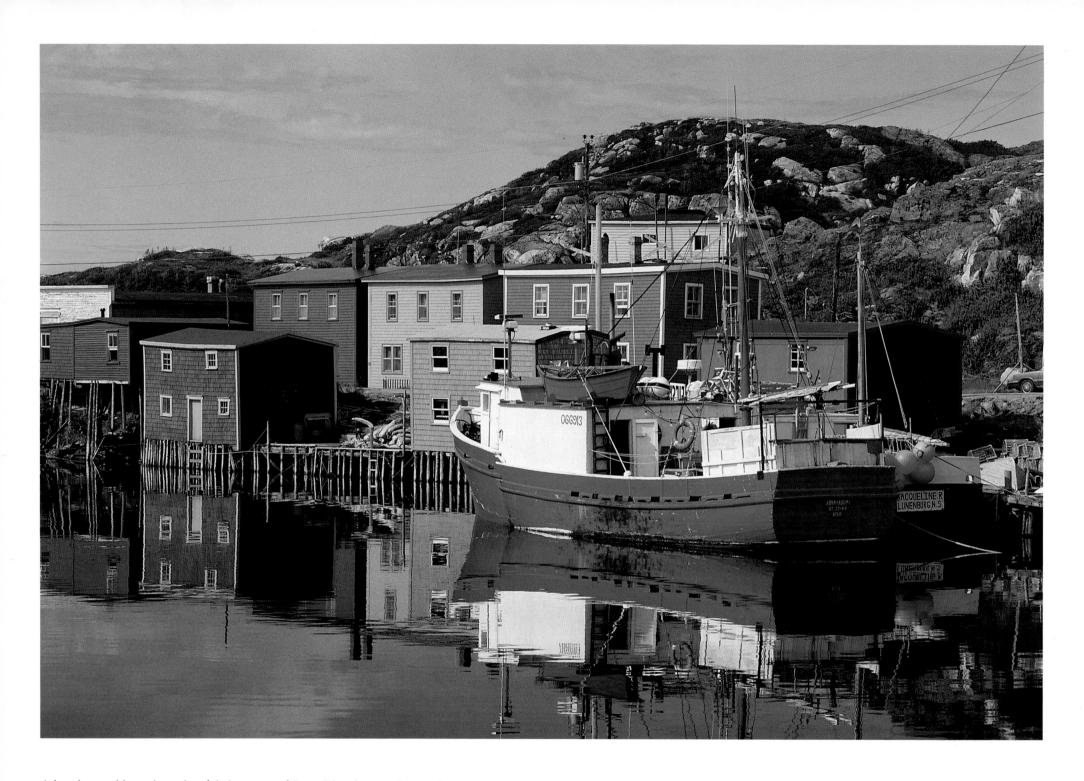

A longliner adds to the colourful character of Rose Blanche, on the southwest coast.

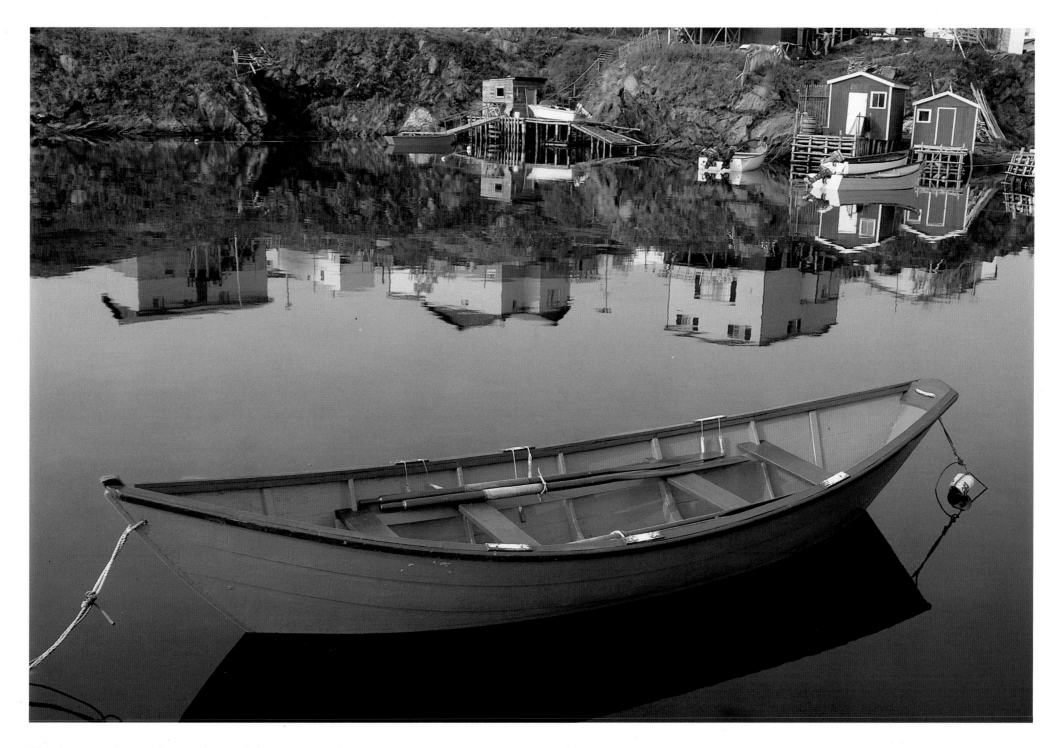

The dory is no longer the workhorse of the inshore and schooner
fisheries, but in places like Burgeo it can still be found.

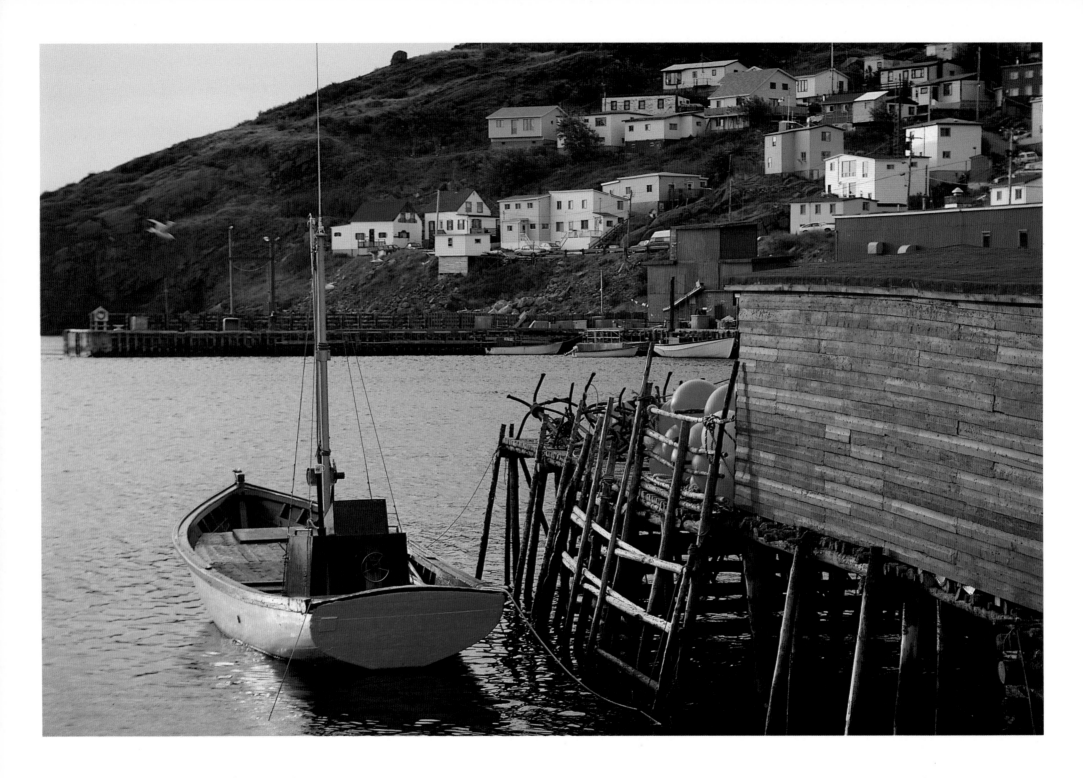

A tranquil morning in the village of Petty Harbour.

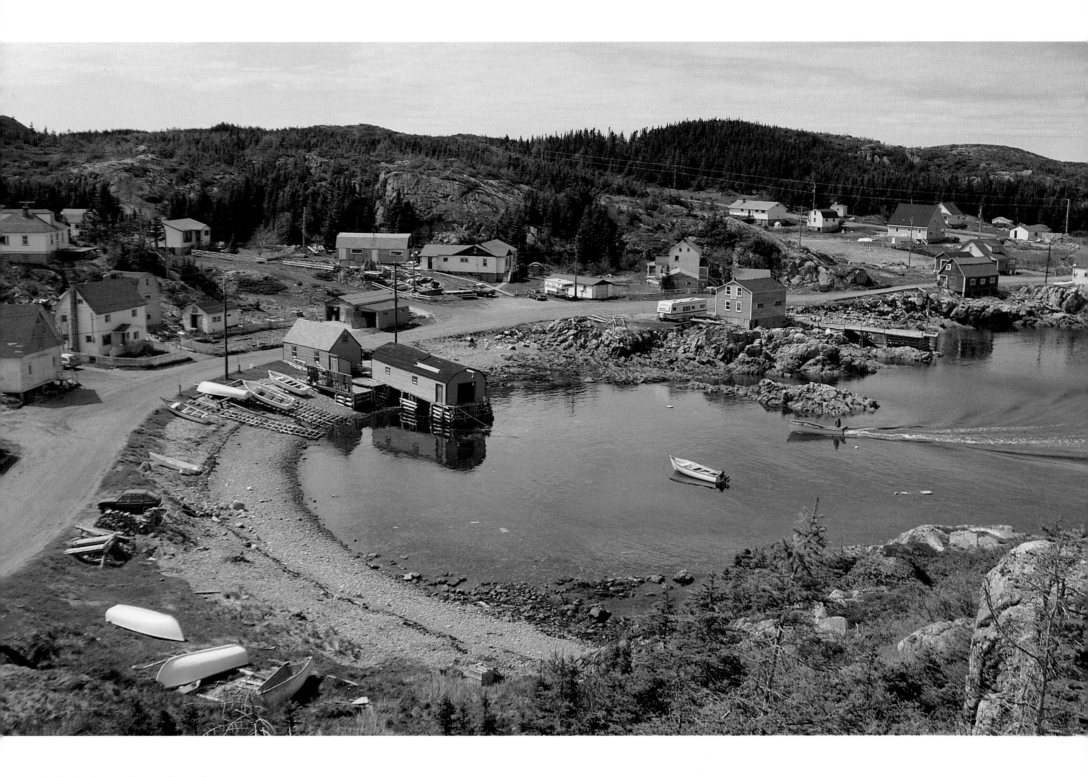

Little Harbour, Notre Dame Bay, is true to its name.

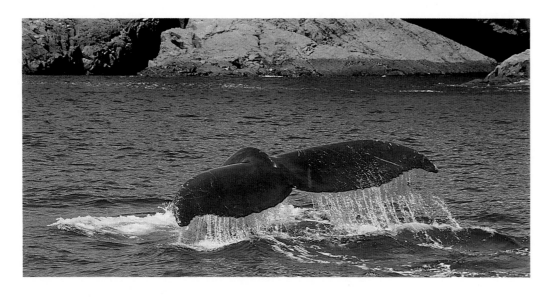

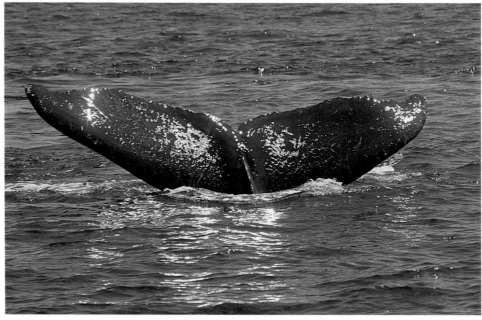

Humpback whales and colonies of seabirds populate the Witless Bay
Ecological Reserve on the Southern Shore.

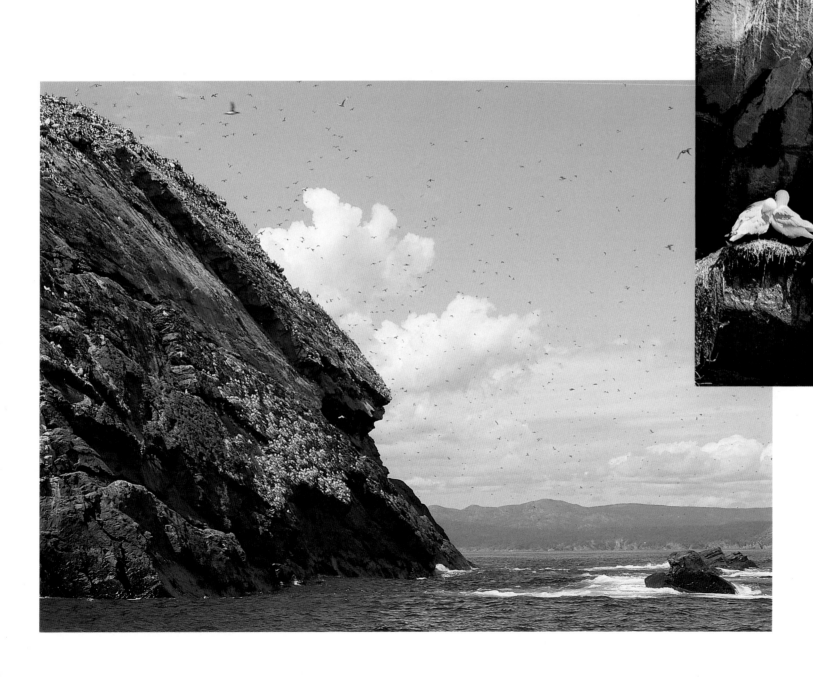

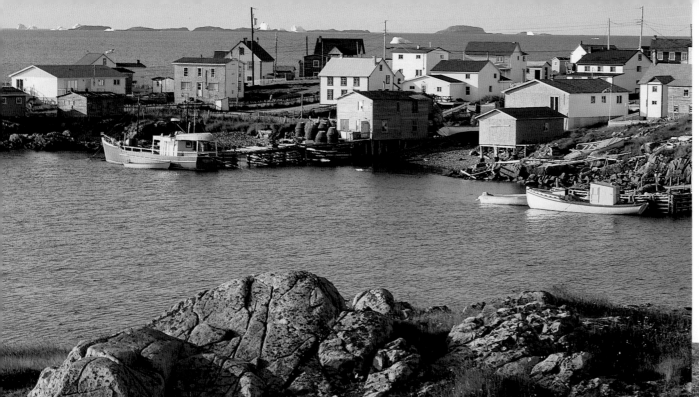

The community of Barr'd Islands lies on the
northern end of Fogo Island.

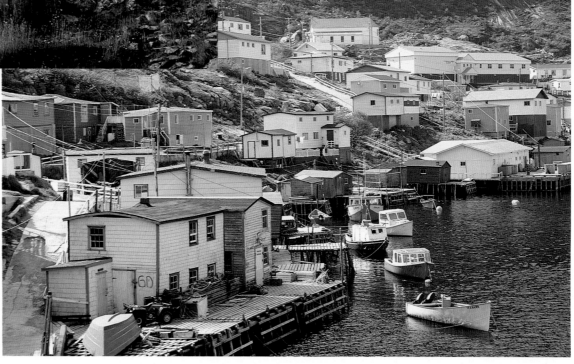

Francois, on the south coast, has no roads or
automobiles and can only be reached by boat.

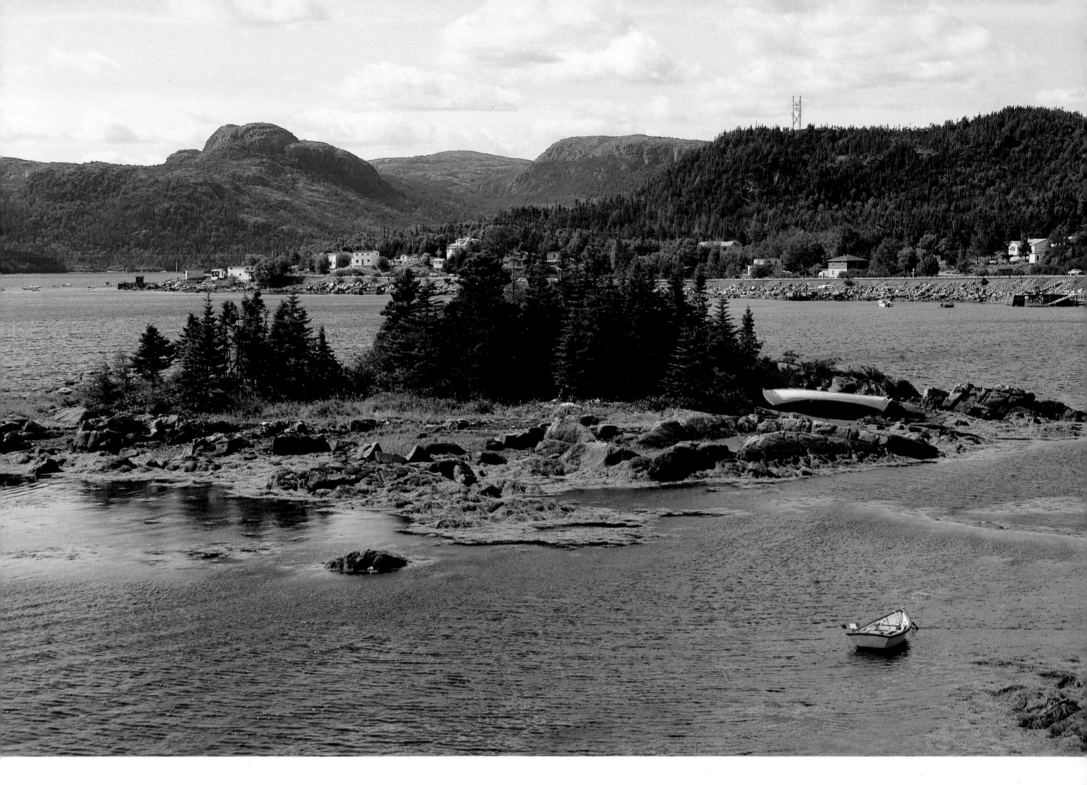

Low tide in the arm near Swift Current.

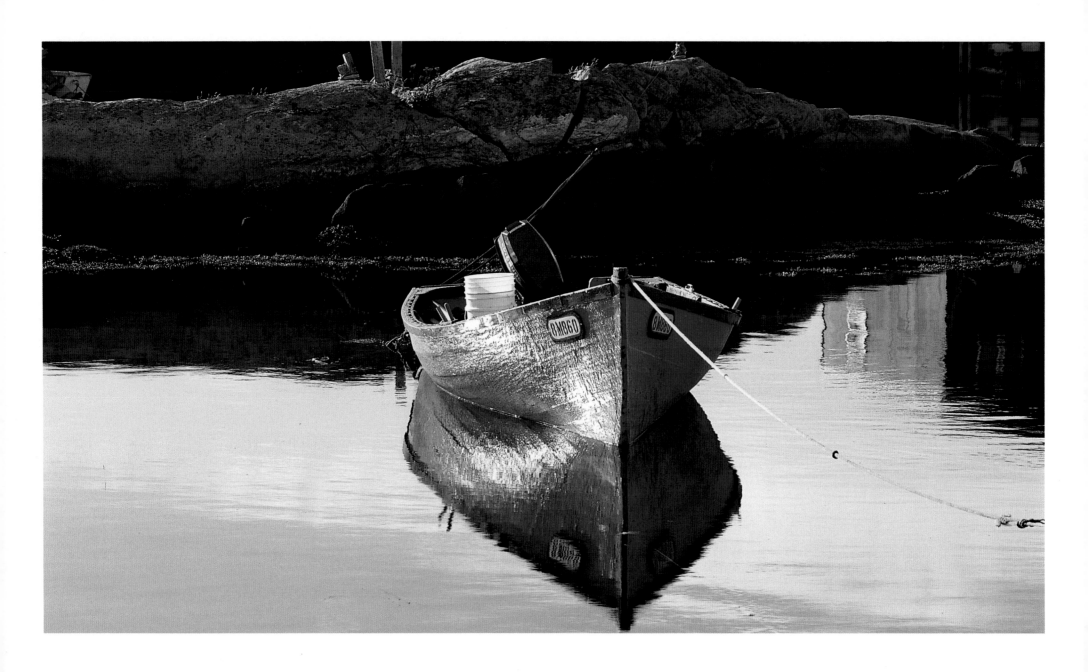

Evening at Isle aux Morts (*Isle of the Dead*), so named for the
many marine disasters that have occured in the waters offshore.

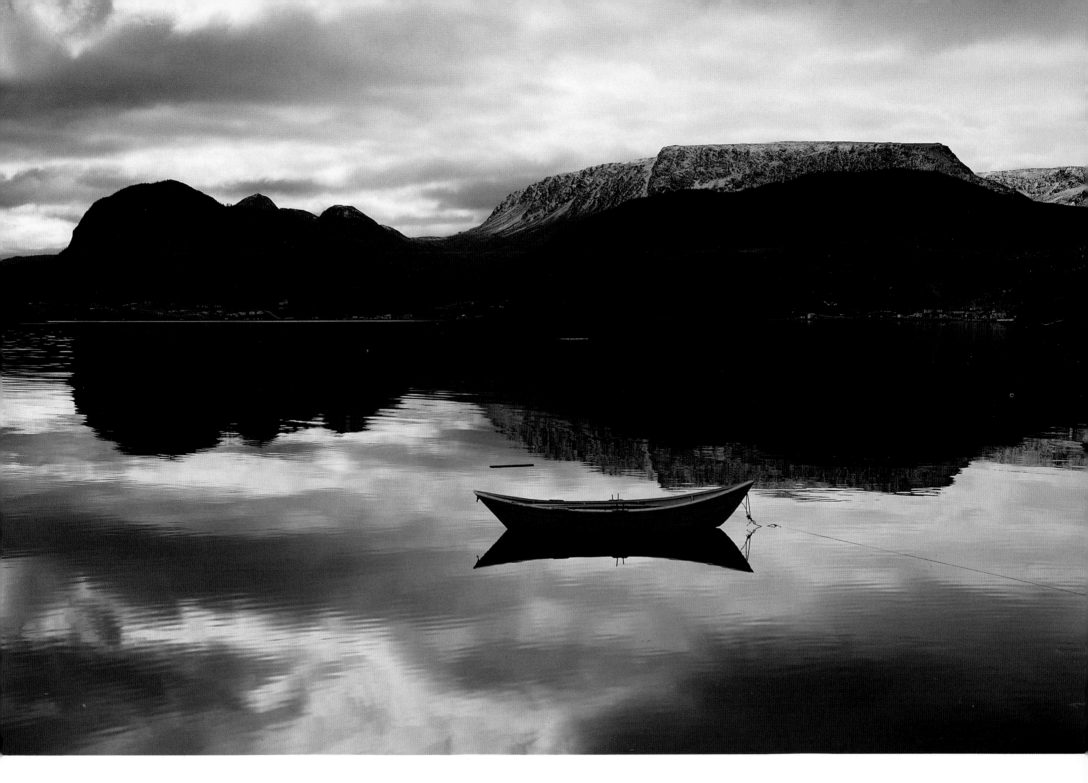

Evening comes as well to Woody Point, with the distinctive Tablelands as a backdrop.

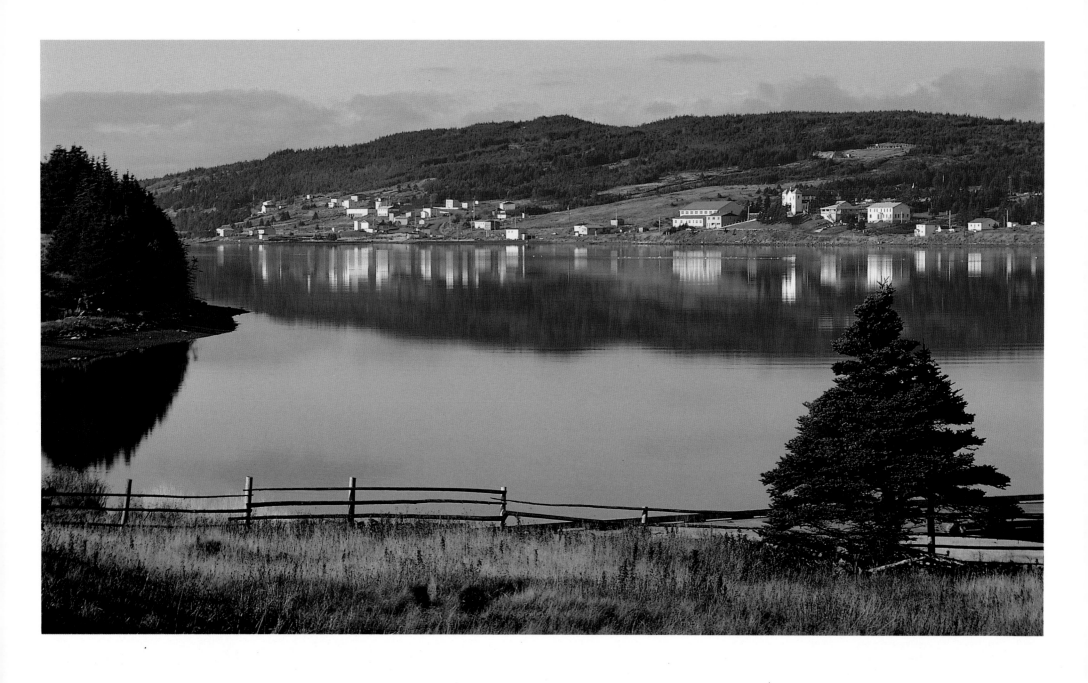

Mount Carmel, St. Mary's Bay

"Although in cloathes, company, buildings faire,
With England, Newfoundland cannot compare;
Did some know what contentment I found there,
Alwayes enough, most times somewhat to spare."
–Robert Hayman, 1628

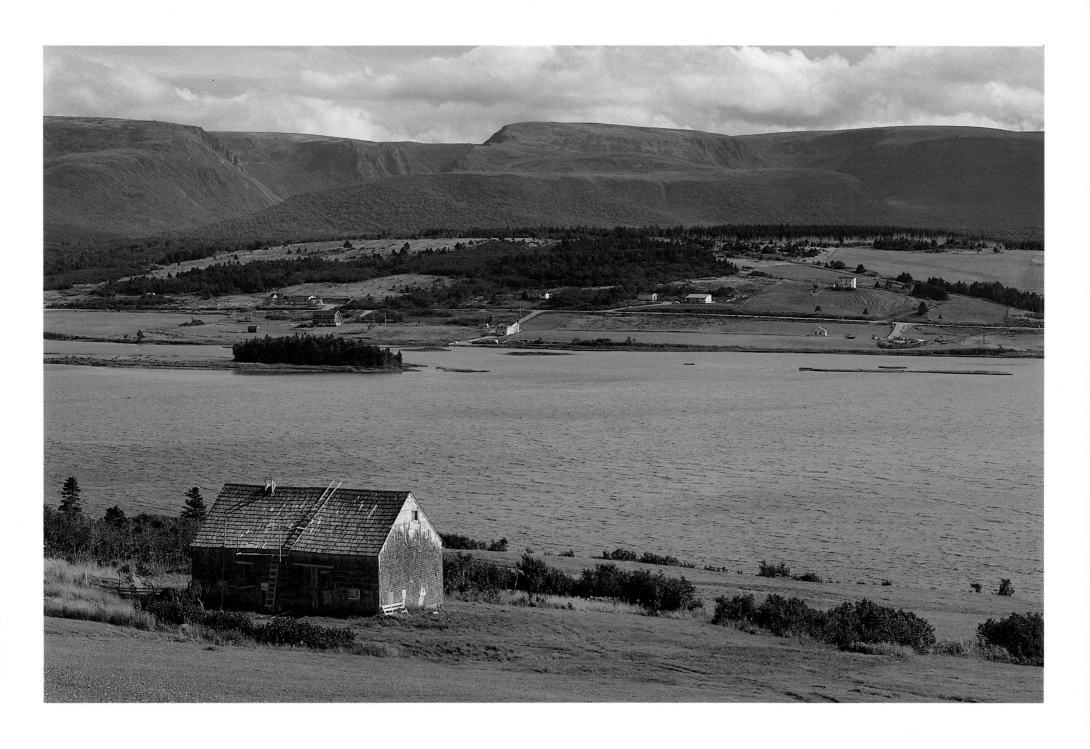

Grand Codroy River

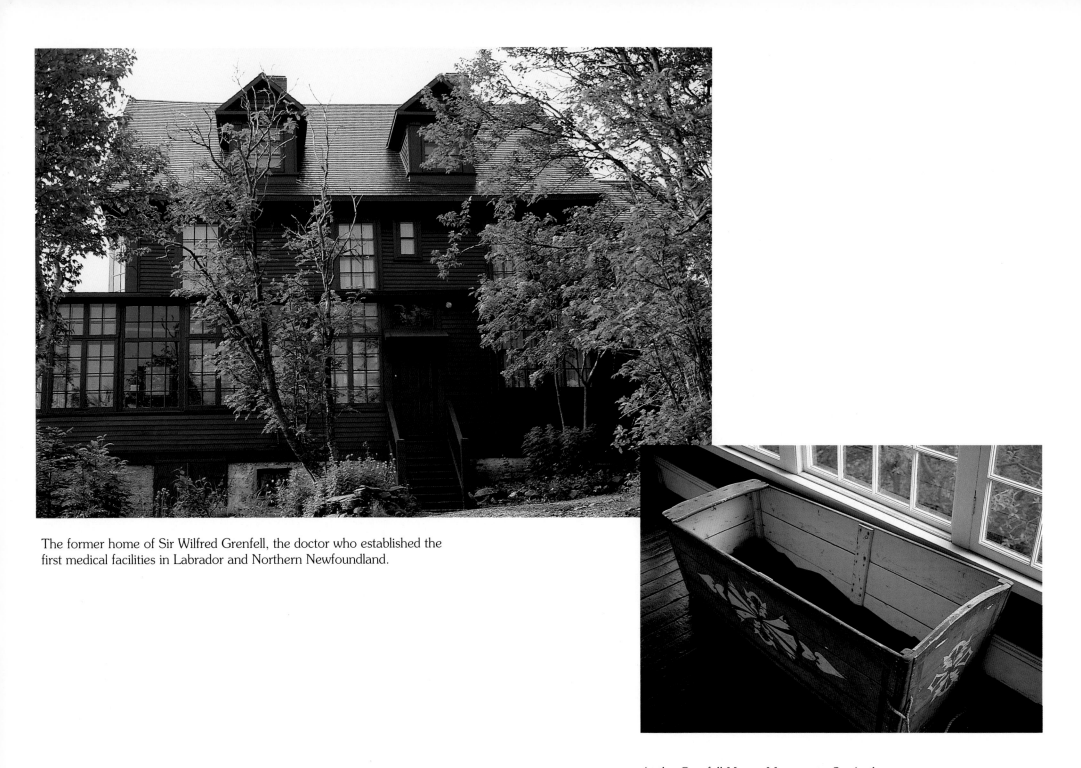

The former home of Sir Wilfred Grenfell, the doctor who established the first medical facilities in Labrador and Northern Newfoundland.

At the Grenfell House Museum in St. Anthony, Labrador's first "ambulance" is on display.

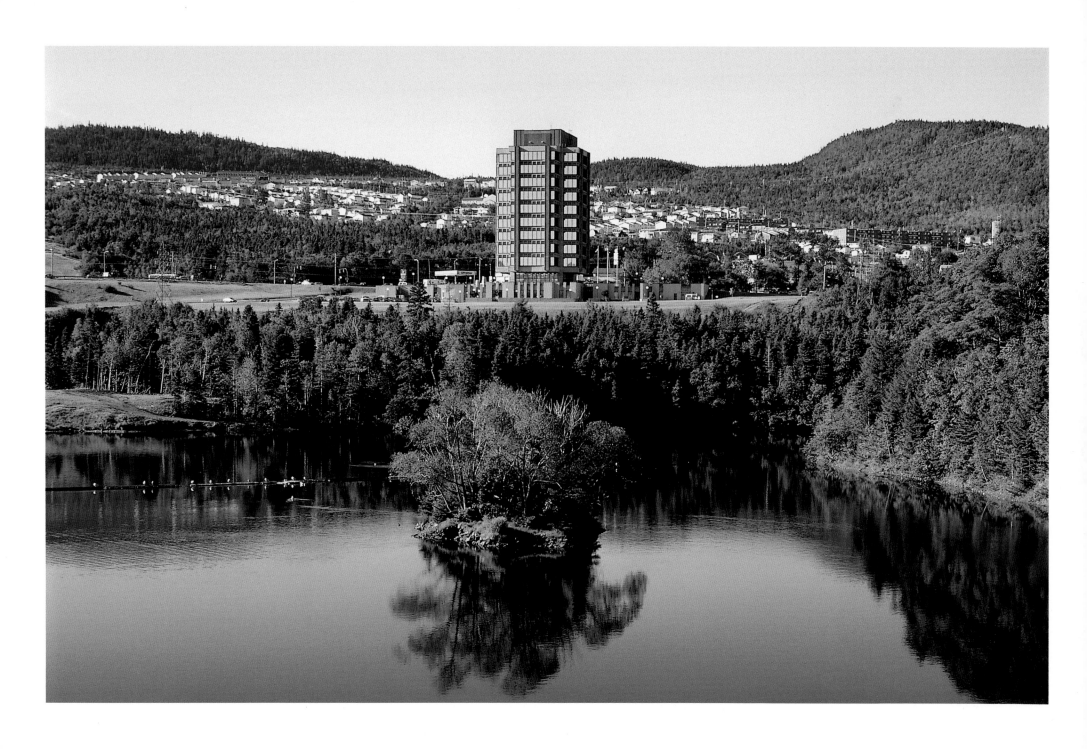

Corner Brook, the province's west coast city, as seen from the Glynmill Inn.

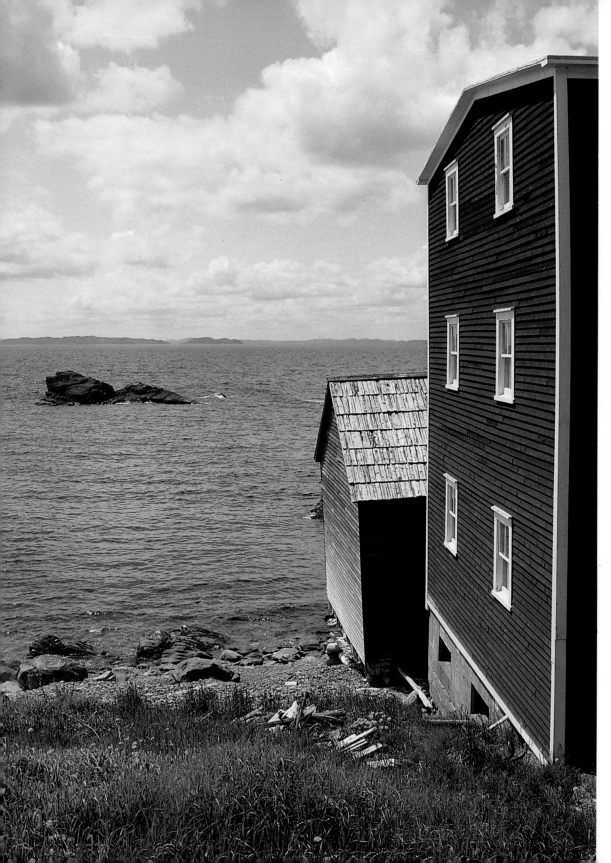

Red buildings at Red Cliff, Bonavista Bay.

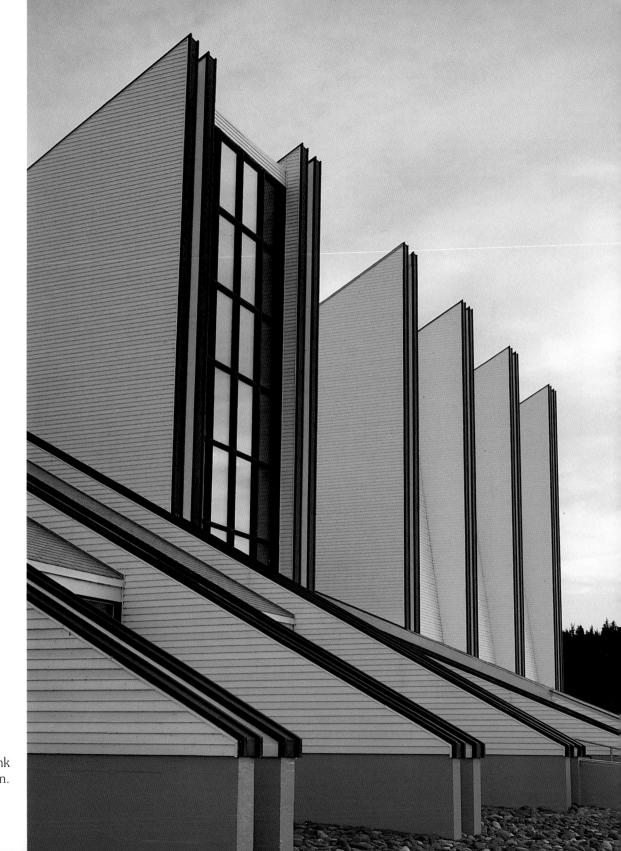

The modern lines of the Grand Bank
Museum belie the long history of the town.

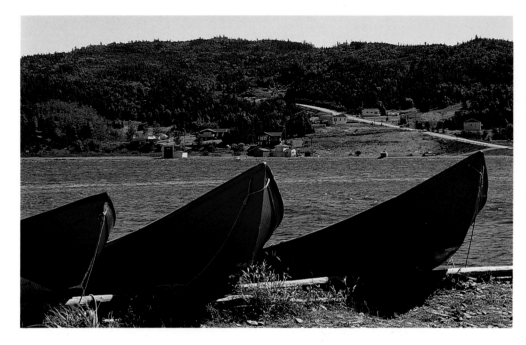

Boats on a slipway at Frenchman's Cove,
near the mouth of Humber Arm.

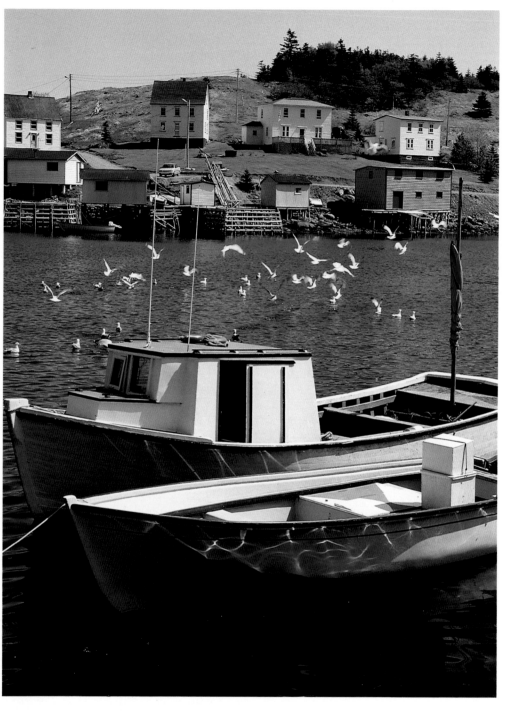

Petit Forte is no longer isolated—a new road now connects the
village to the rest of the Burin Peninsula.

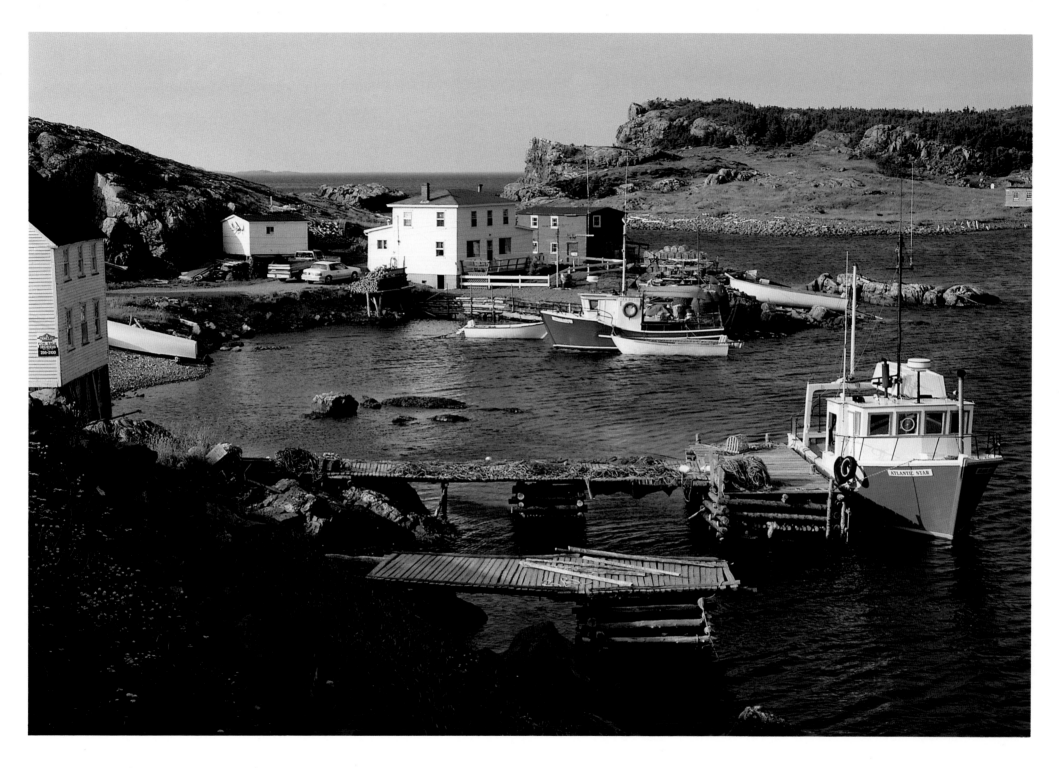

The community of Salvage, at the extreme tip of the Eastport Peninsula.

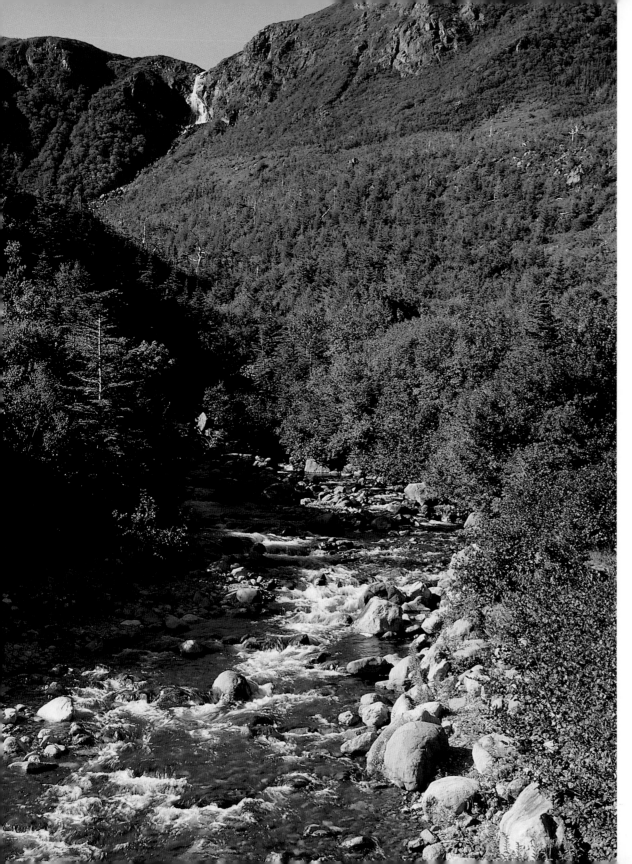

Rattling Brook Falls in the Humber Arm.

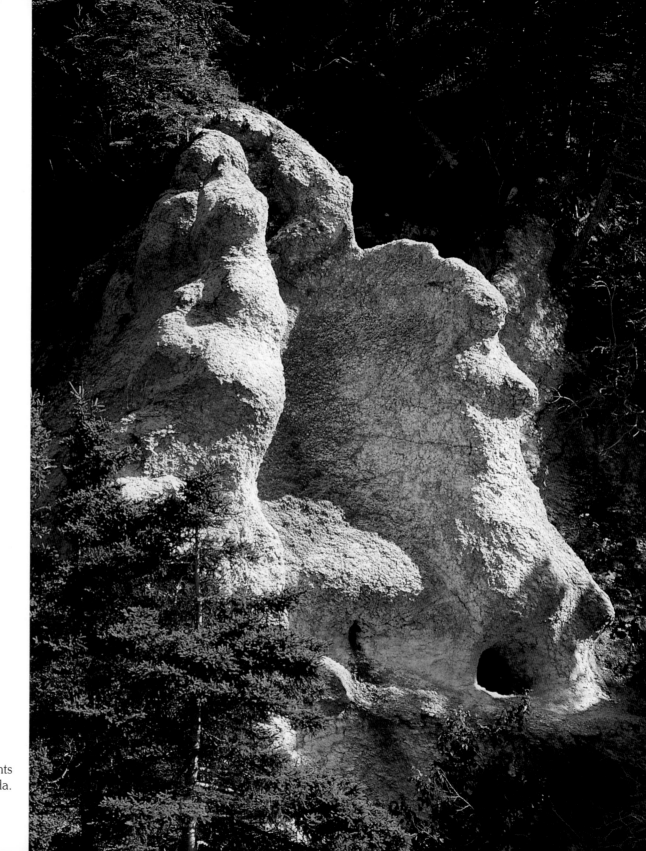

A gypsum outcrop sculpted by the elements
at Romaines, Port au Port Peninsula.

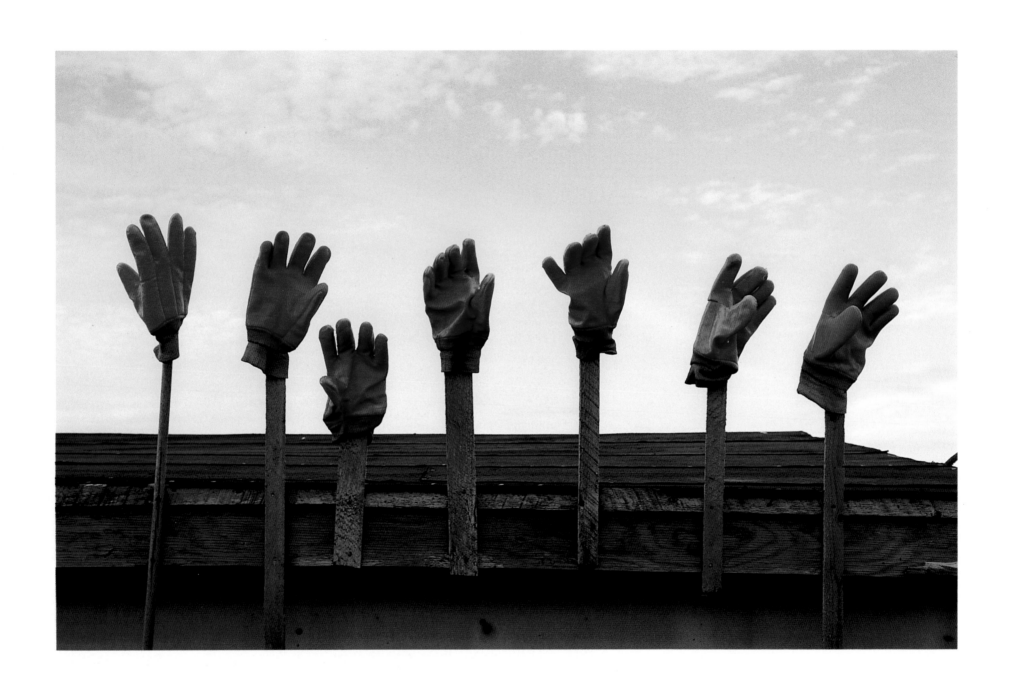

Fishermen's gloves wave from drying sticks at McKay's, St. George's Bay.

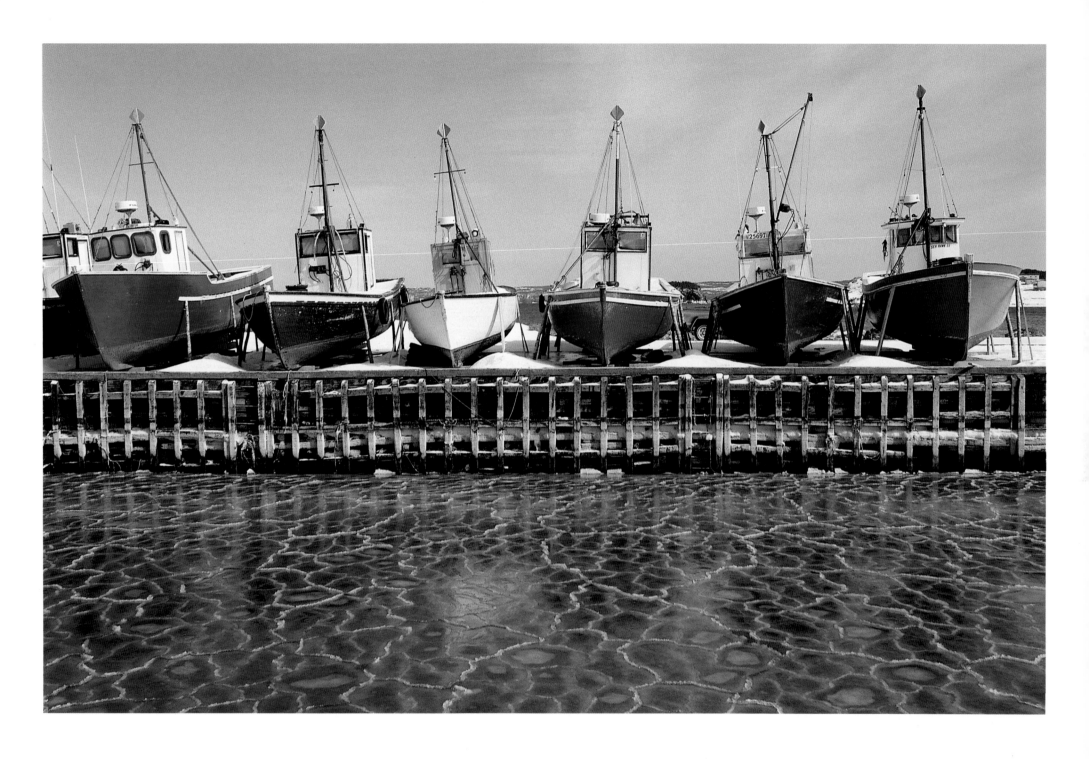

Chapel Arm "caught over" with fishing boats safely arrayed on the wharf.

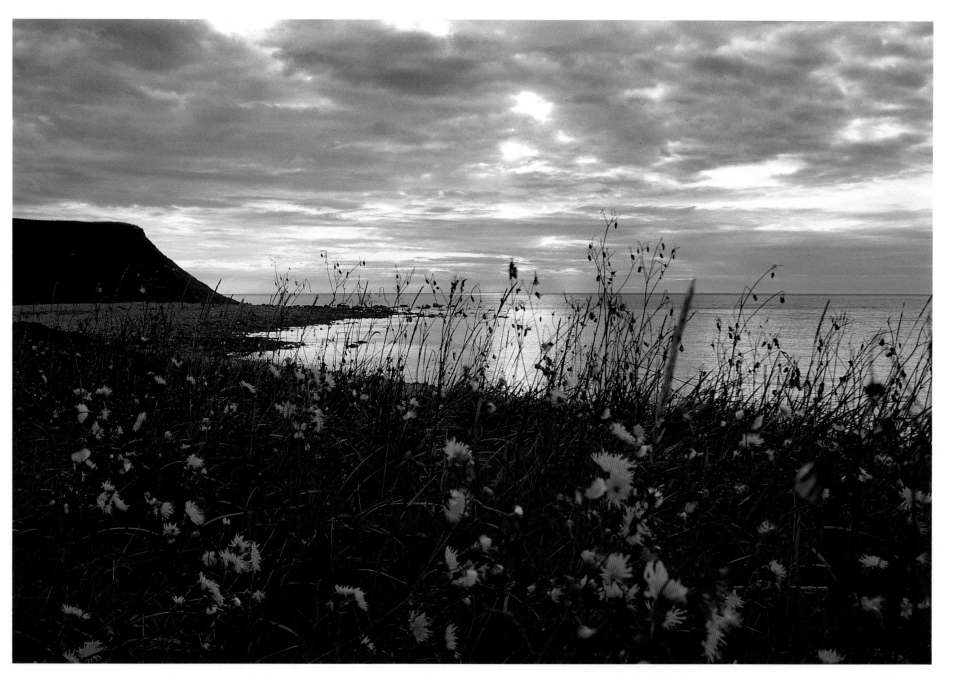

"Sunset and evening star,
And one clear call for me!
And may there be no moaning of the bar
When I put out to sea."

—Alfred, Lord Tennyson

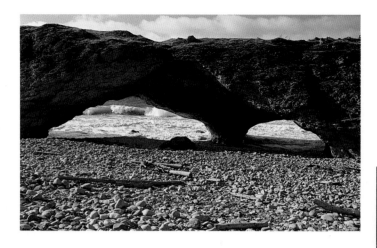

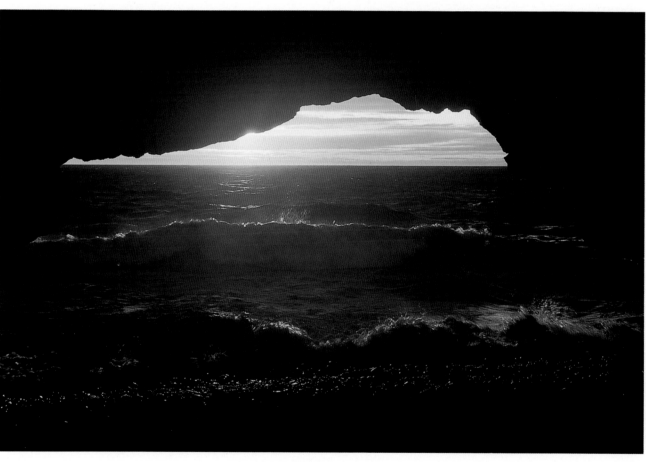

The Arches on the Great Northern Peninsula, where the sea continues to shape the land and the people of Newfoundland and Labrador.

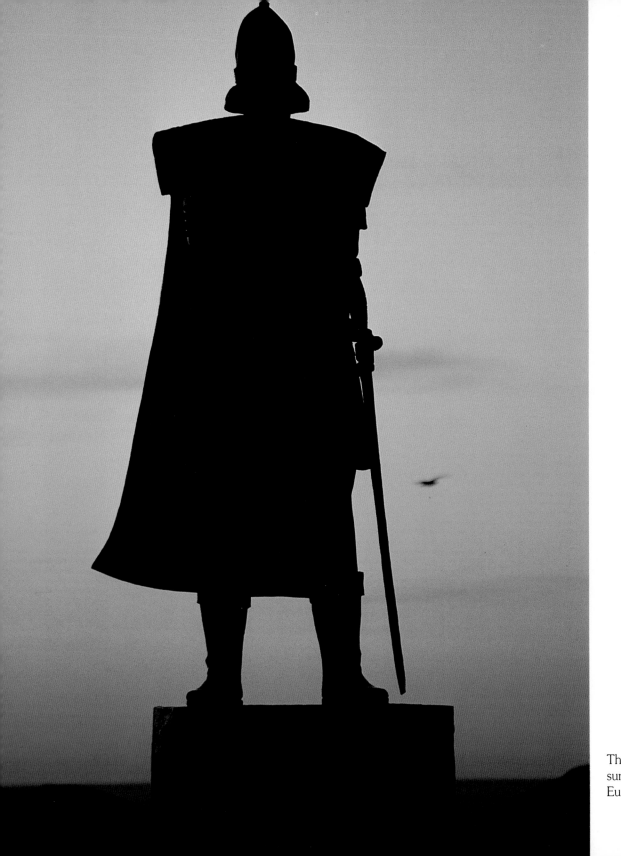

The towering statue of Gaspar Corte Real is silhouetted at sunrise. In 1500 the Portuguese explorer became the first European to enter St. John's harbour.

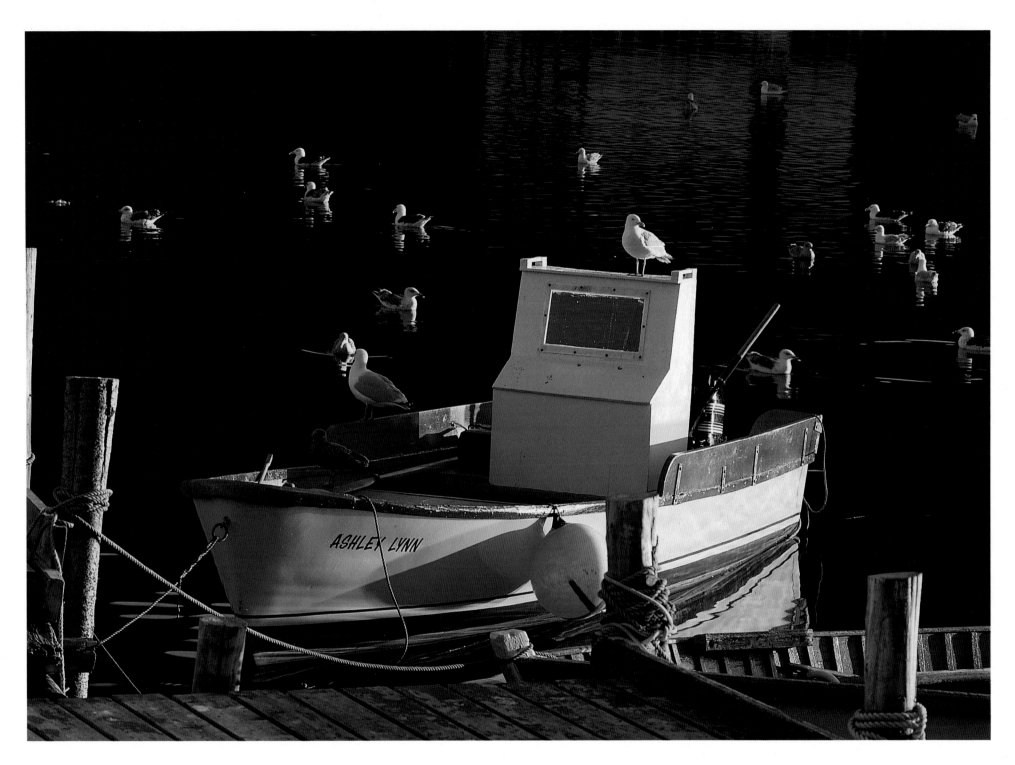

Boats lie idle and seagulls wait in vain as the fishery moratorium drags on.

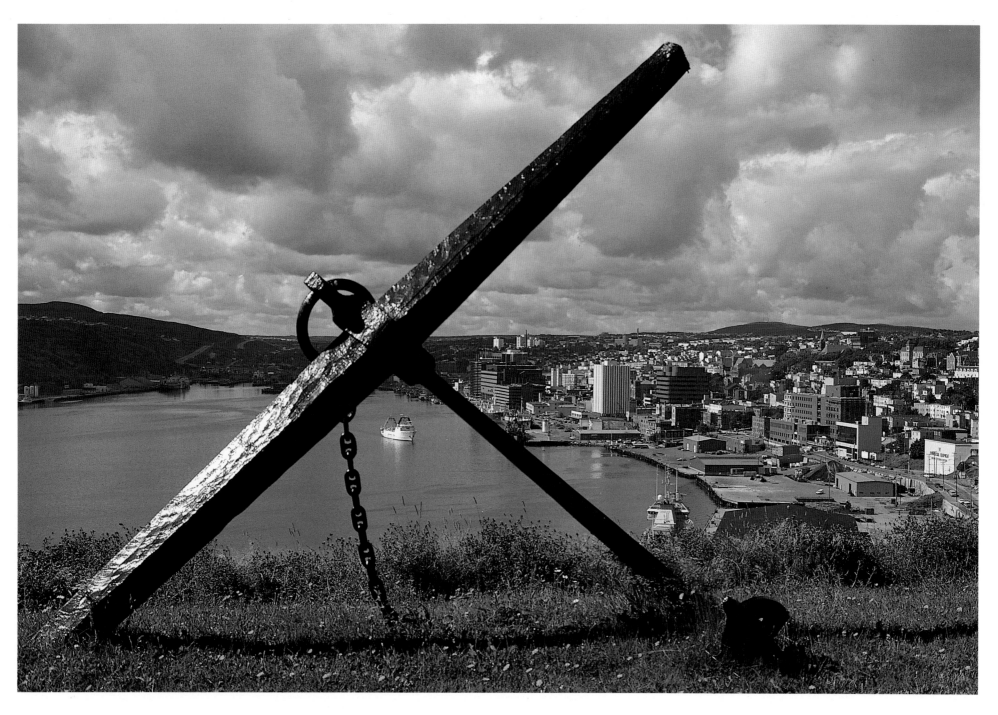

A vessel turning in the harbour is framed by an anchor from a sailing ship. At the height of the Newfoundland fishery the harbour could often be crossed by jumping from one anchored schooner to the next.

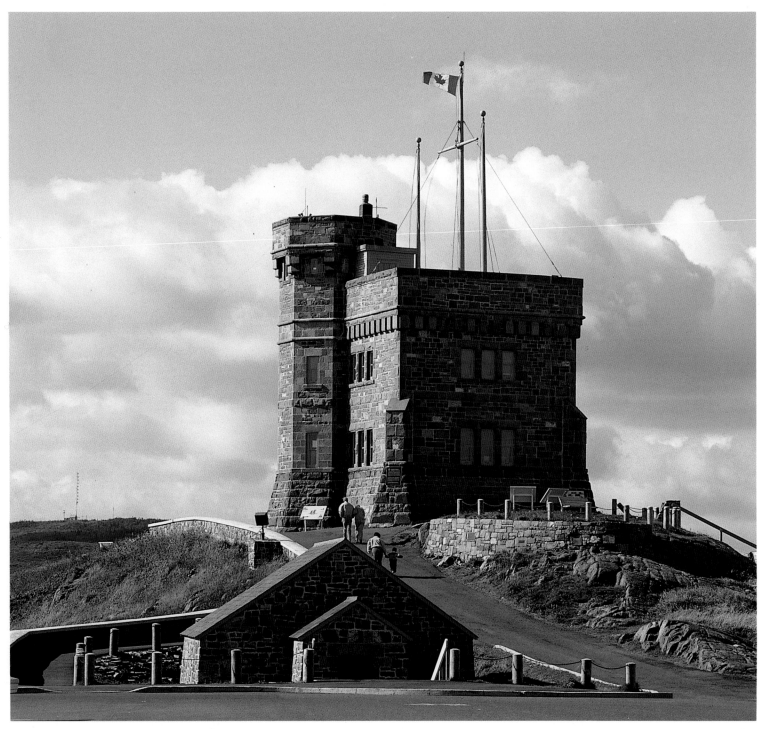

Cabot Tower, the sentinel of St. John's, was completed in 1900. Construction was begun two years earlier to commemorate both Victoria's diamond jubilee and the 400th anniversary of England's claim to the island.

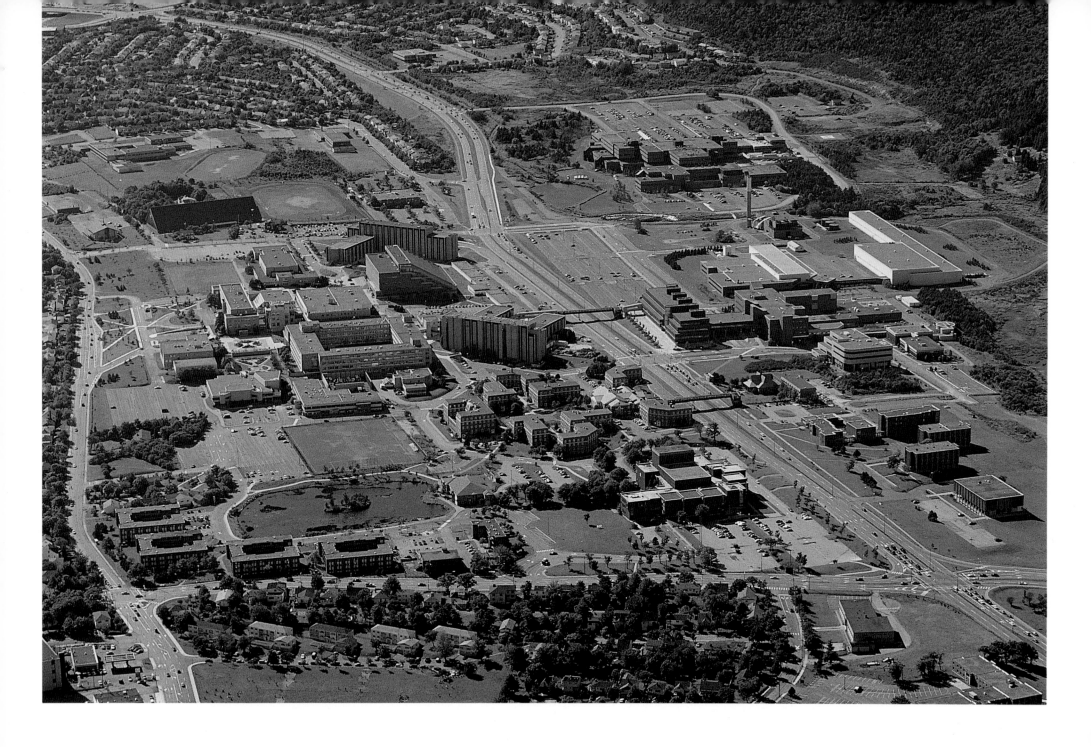

A view of Memorial University, founded after the Great War
as a memorial to those who died for king and country.

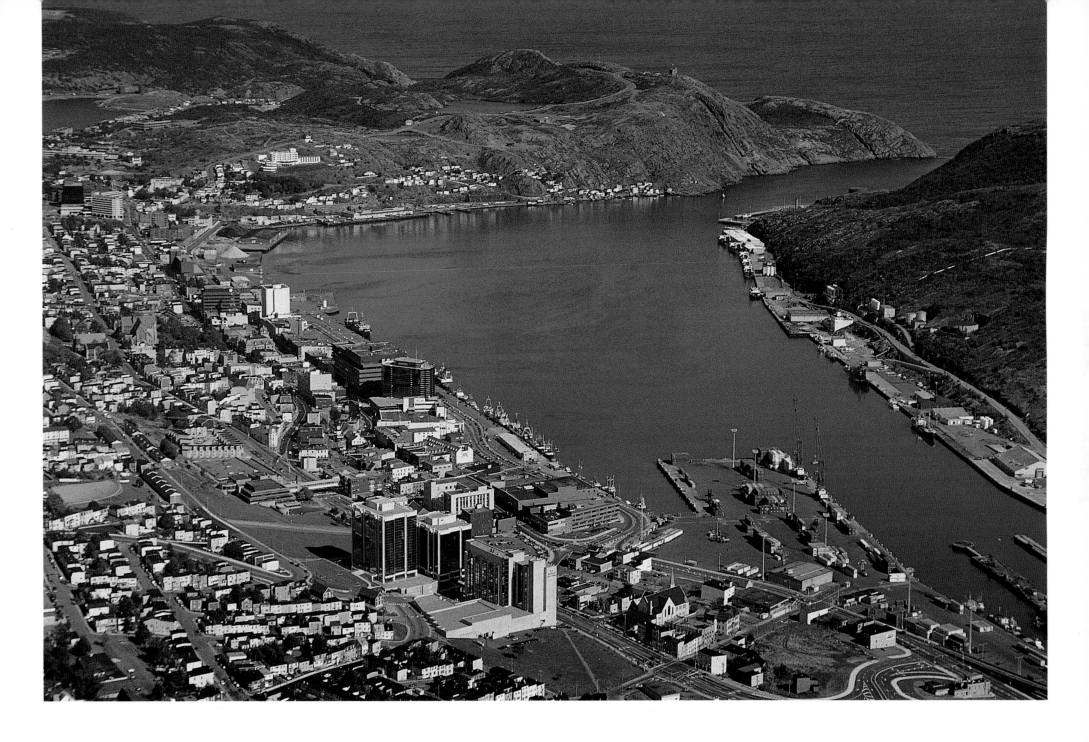

Much has changed since Stephen Parmenius accompanied Sir Humphrey Gilbert to St. John's in 1583. In a letter to England he remarked that the shores of the harbour were densely wooded with pine trees.

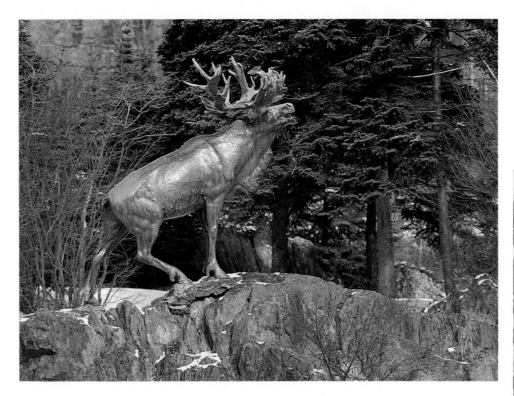

"He stands aloft, full proud and fierce
Roaring forth his challenge to the foes. . ."

 – Sue Cox, *The Caribou*, in honour of the
 Royal Newfoundland Regiment

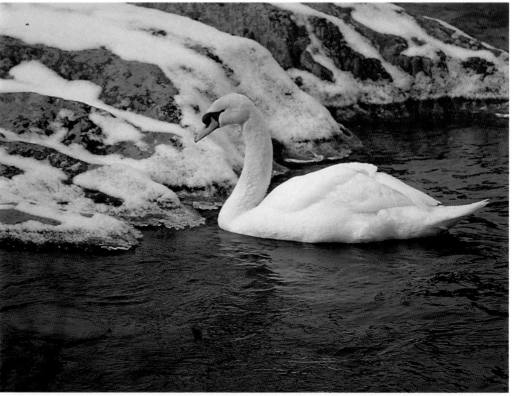

One of Bowring Park swans on the Waterford River, which flows through the park.
The swans are a popular attraction for the thousands of children who visit each year.

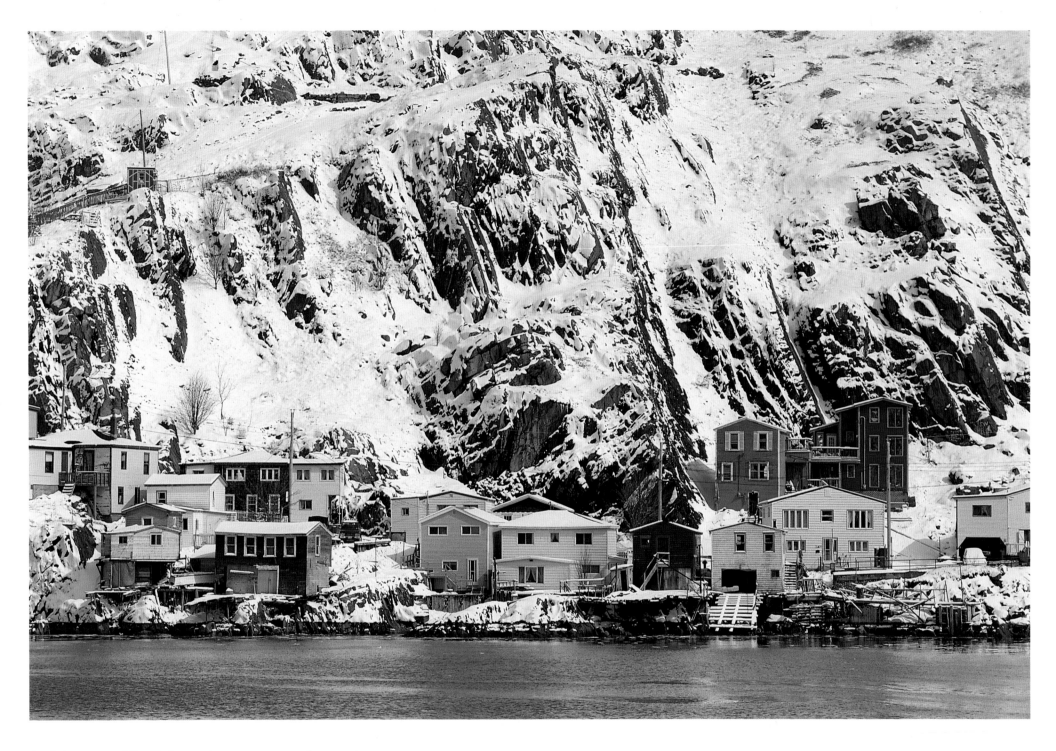

A winter scene at the Battery, where cannon emplacements
helped defend the harbour from the Dutch in 1673.

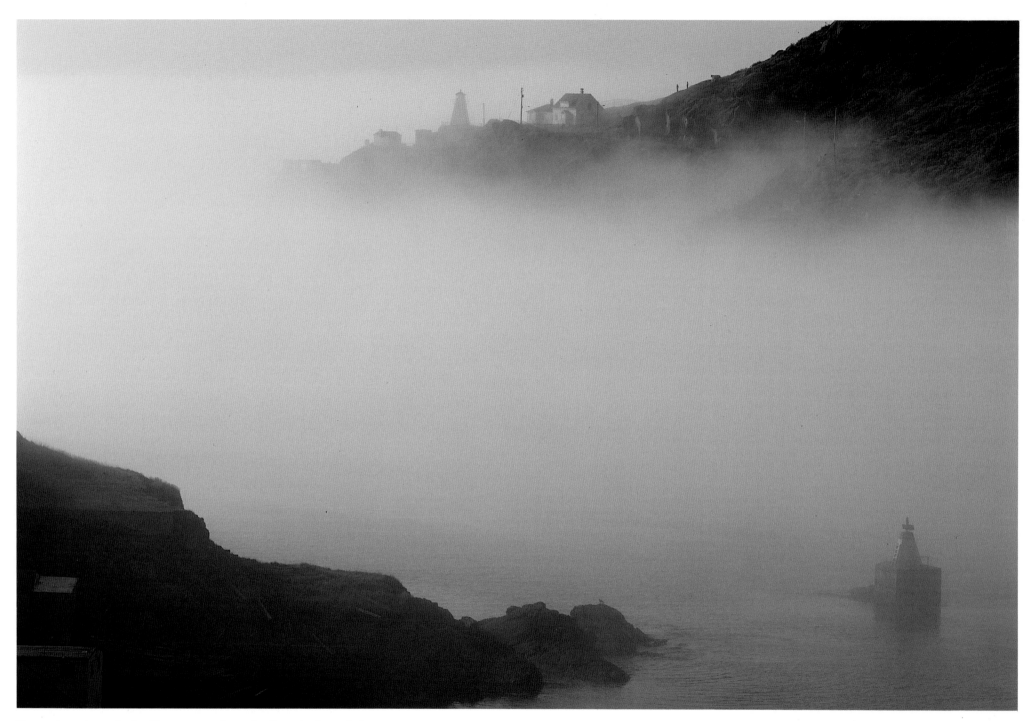

Fog creeps through the Narrows, making the Fort Amherst light
and foghorn a necessity for navigating the harbour.

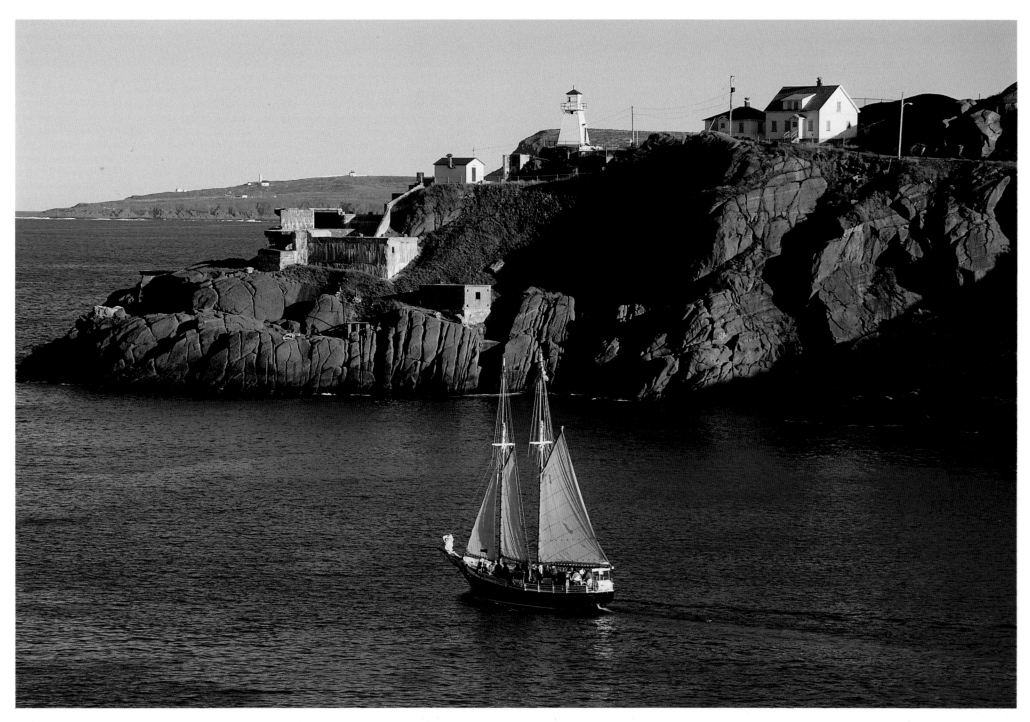

Later the same day a tourist boat leaves the harbour in brilliant sunshine.
St. John's is famous for sudden changes of weather.

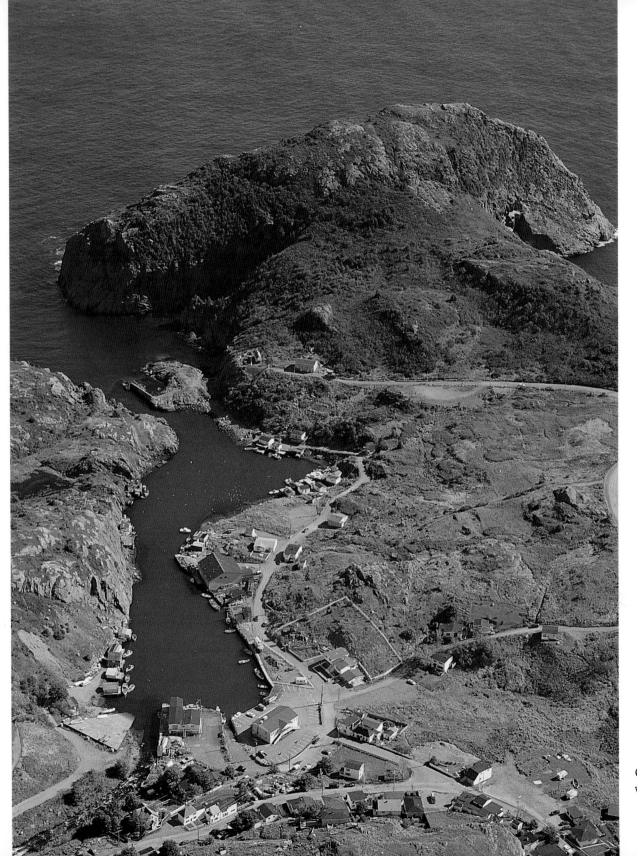

Cuckold's Head looms above Quidi Vidi. The tiny harbour and village still retain a distinct character within the city.

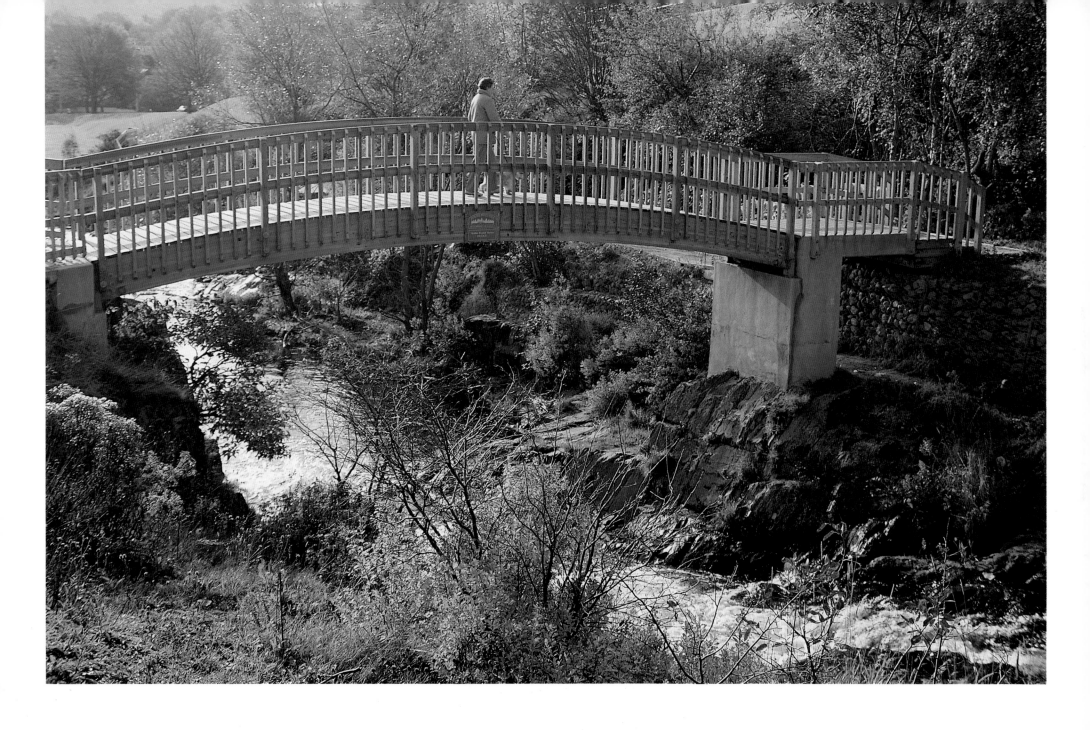

A footbridge spans the Rennie's River where a water-driven mill once operated.
A community foundation has established a popular walking trail along the river's length.

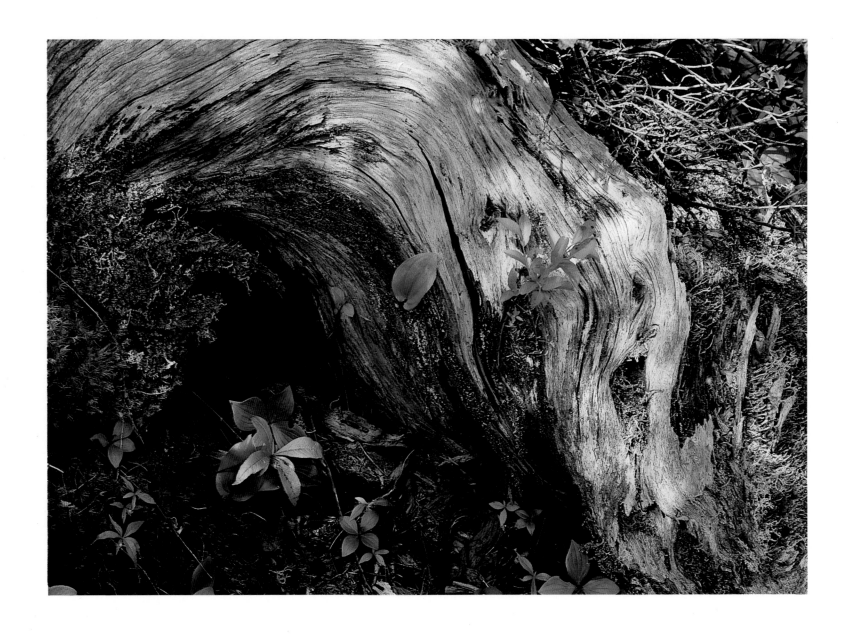

The gnarled stump of a long-dead tree provides shelter
for new life in the Botanical Garden at Oxen Pond.

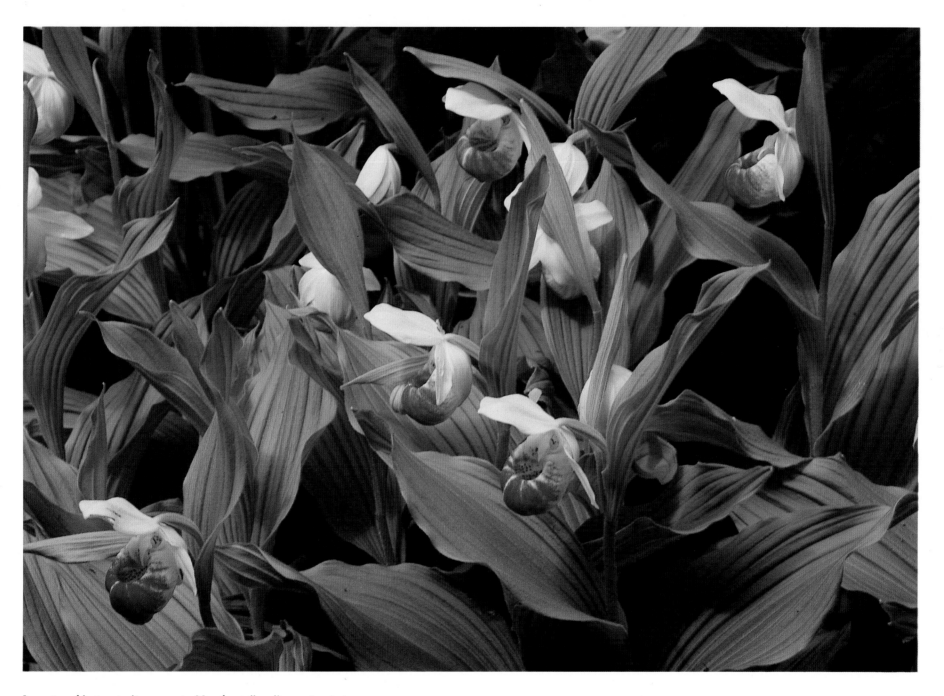

In spite of being indigenous to Newfoundland's west coast,
a Showy Lady's Slipper thrives at the Botanical Garden.

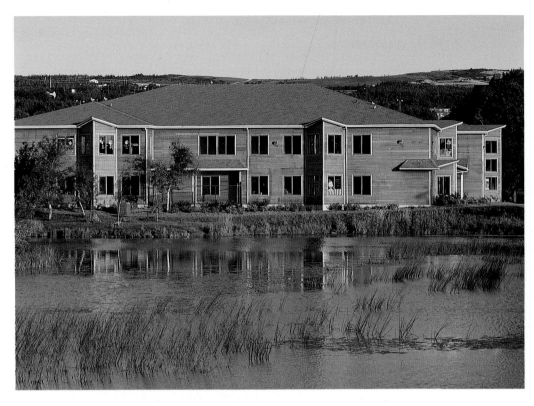

The new pre-school at Memorial University allows children to enjoy the plant and bird life of Burton's Pond.

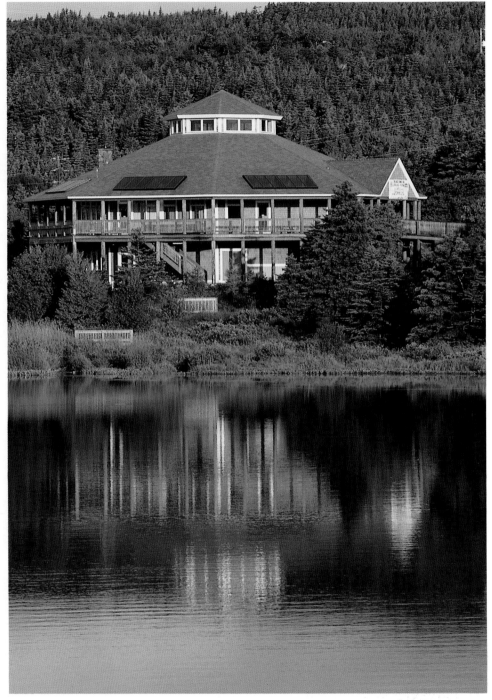

The Freshwater Resource Centre at Long Pond houses North America's only fluvarium, where visitors can observe the underwater life of a typical Newfoundland stream.

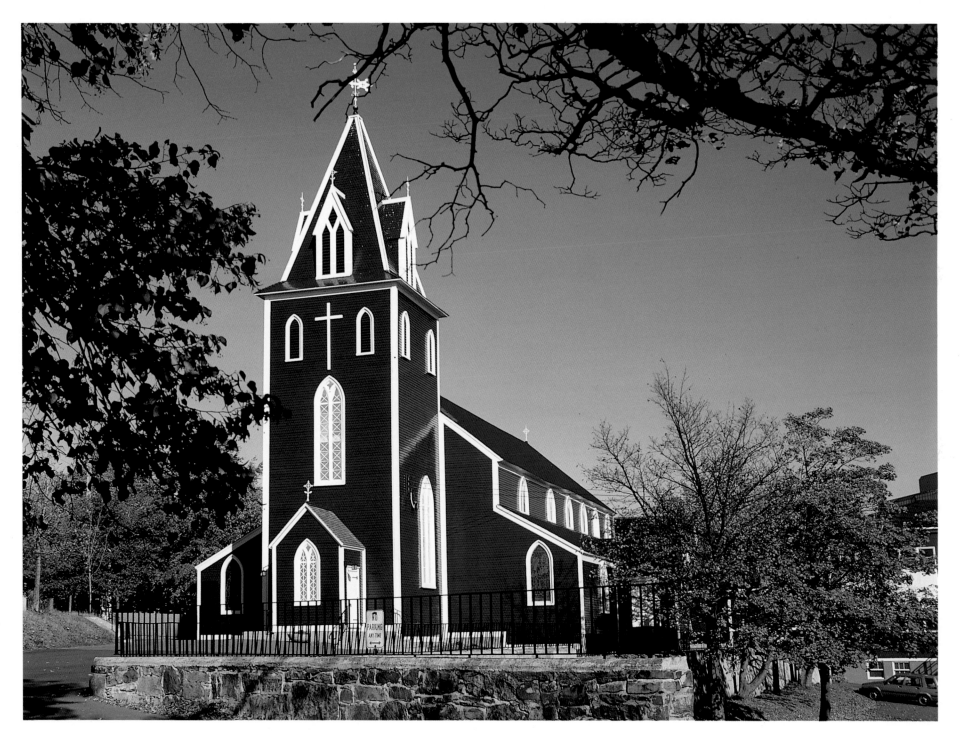

St. Thomas's Anglican Church, also known as the Old Garrison
Church, survived the Great Fires of 1846 and 1892.

"Joyless is the day's return,
Till thy mercy's beams I see,
Till they inward light impart,
Glad my eyes, and warm my heart."

– John Wesley

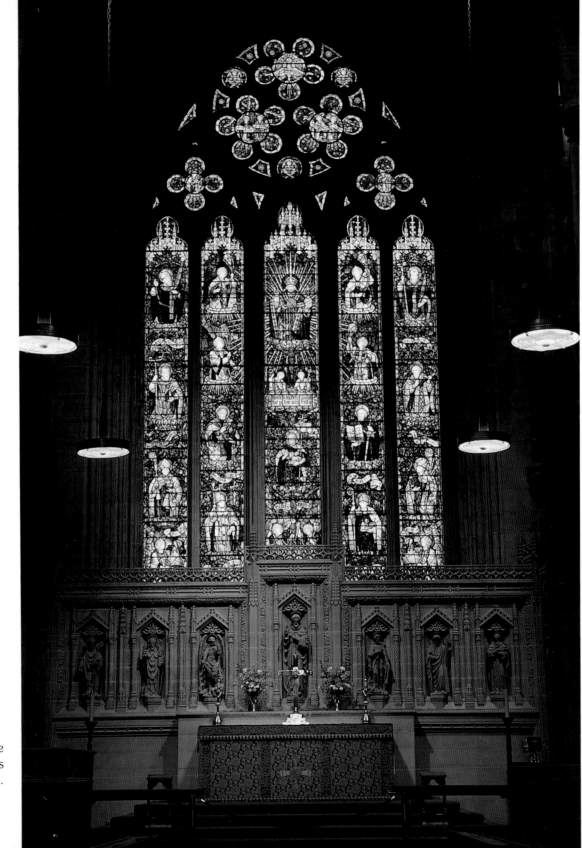

A stained glass window situated above the altar in the Cathedral of St. John the Baptist. The work, known as "Tree of the Church", was installed in 1911.

Near Carol's Cove

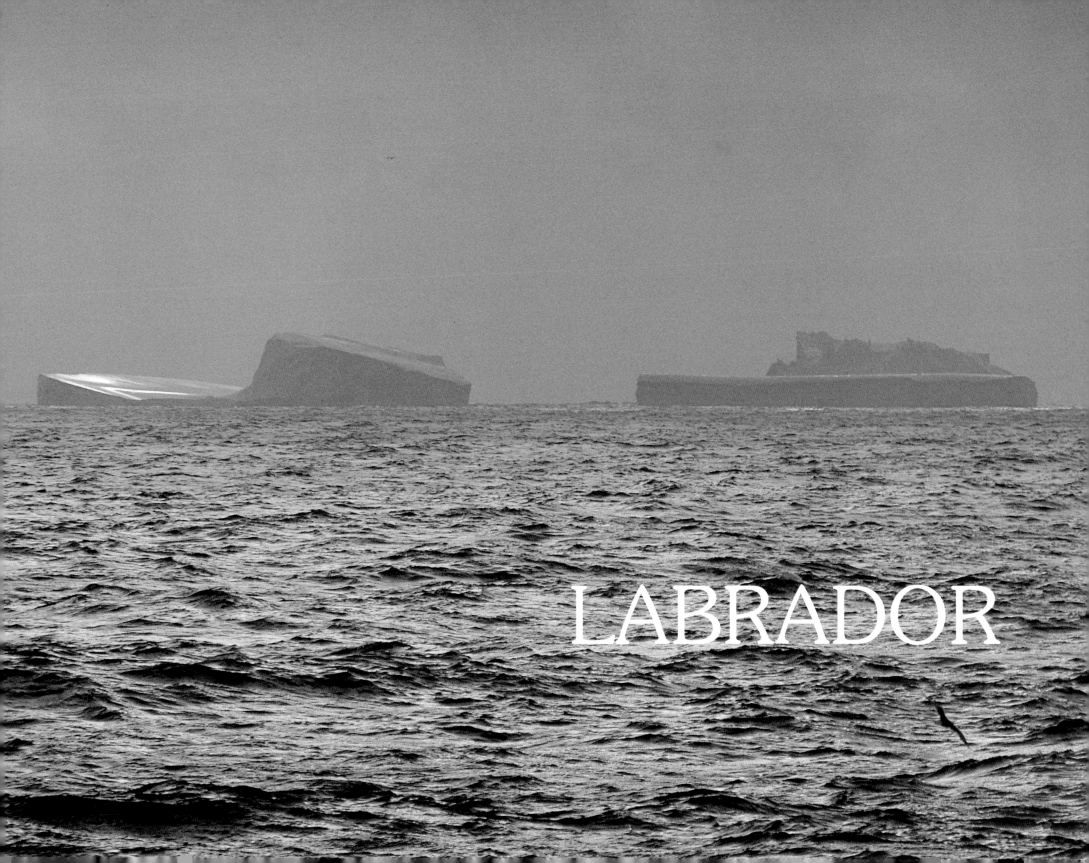

LABRADOR

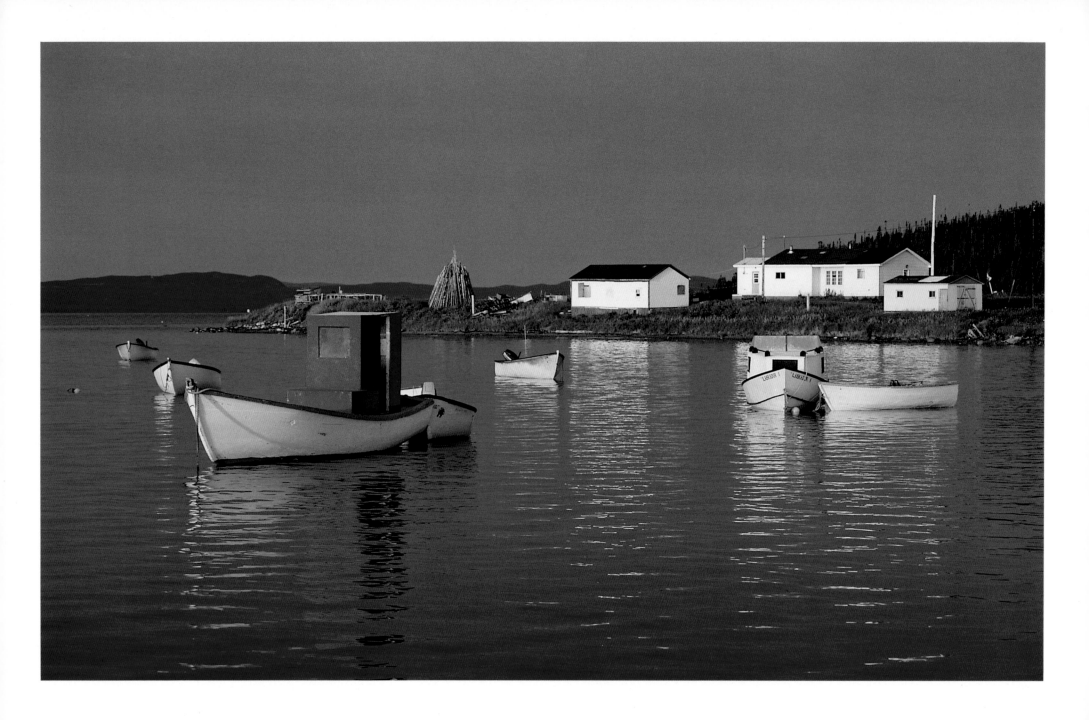

Inshore fishing boats in Postville, where the
Dorset Eskimos fished four thousand years ago.

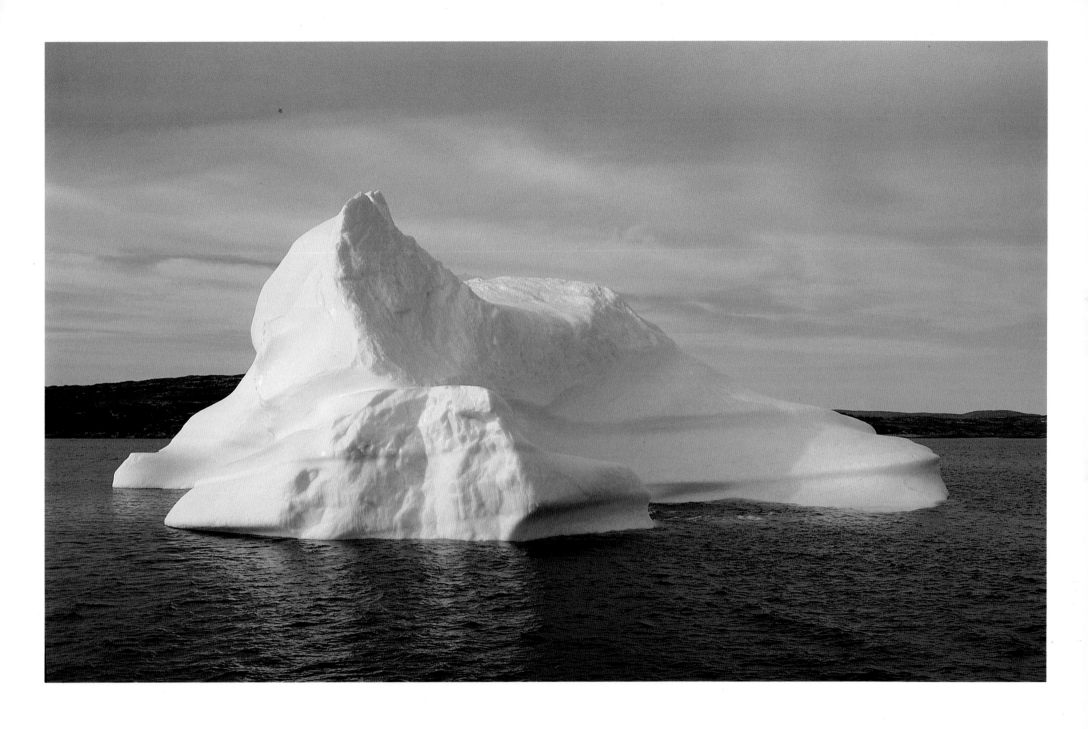

One of Labrador's frequent visitors, near Sandy Hook.

"*The sweet flower of the bakeapple, and other pretty things grow quietly upon this ground, which is scarce habitable for man.*"

— Robert Lowell, 1858

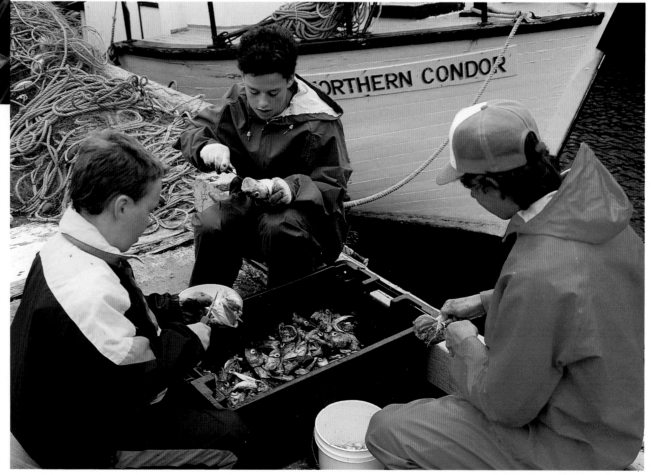

Three sons of Red Bay cutting a meal of cod tongues on the community wharf.

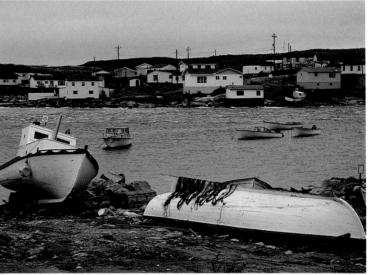

Mary's Harbour, settled by fishermen two centuries ago, is now an important centre of coastal trade.

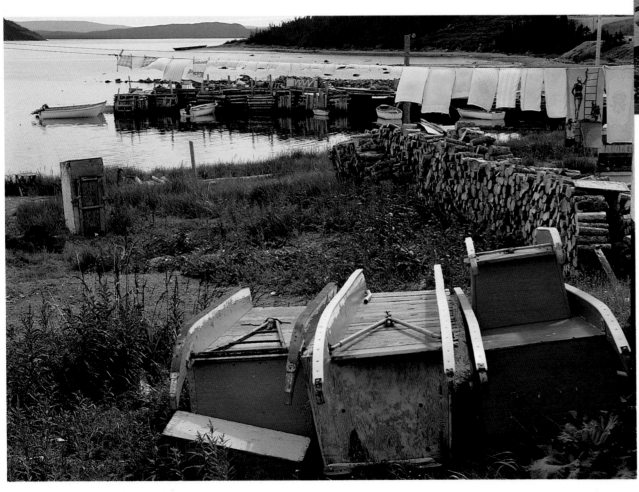

Komatiks and woodpiles in Postville lie ready for another long Labrador winter.

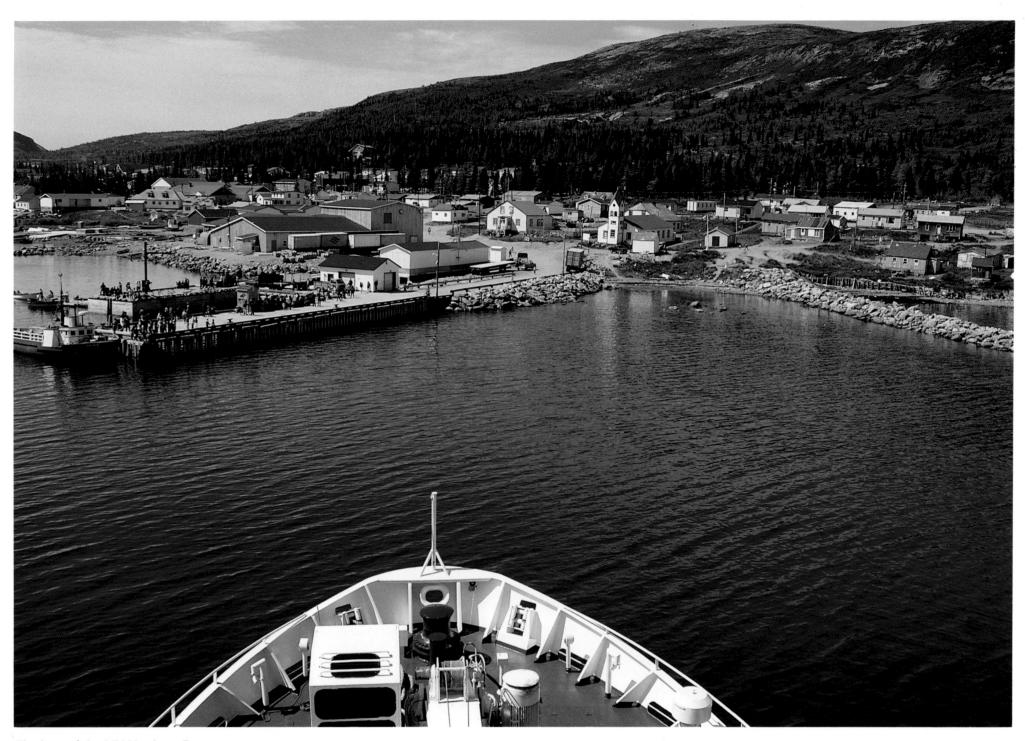

The bow of the MV Northern Ranger swings
around for docking at the wharf in Nain.

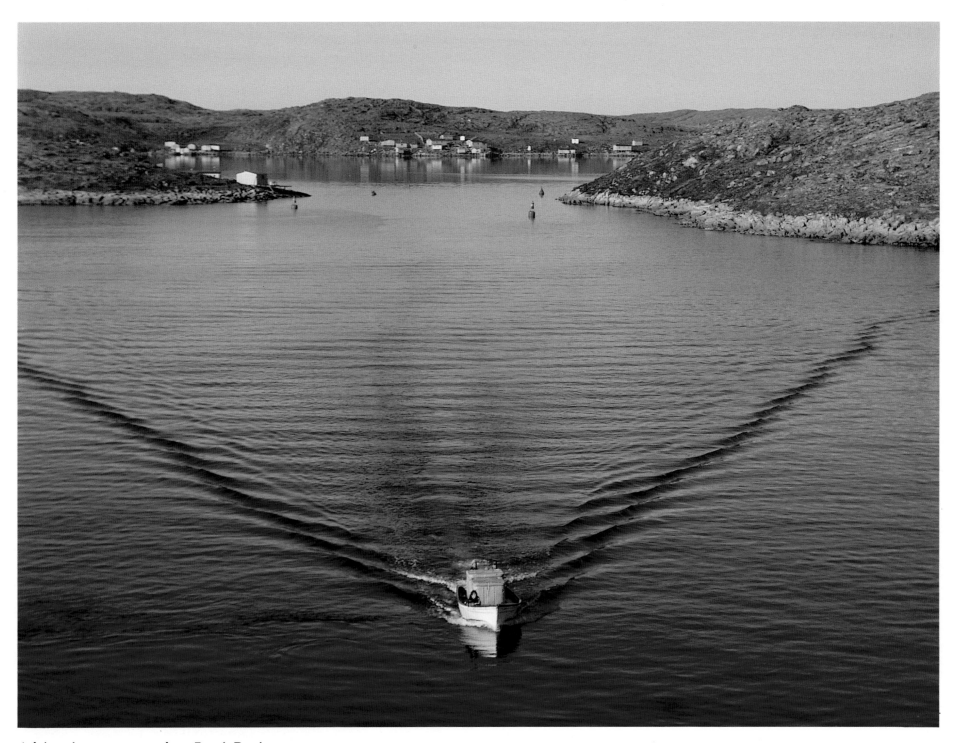

A fishing boat steams out from Punch Bowl to meet
the Northern Ranger.

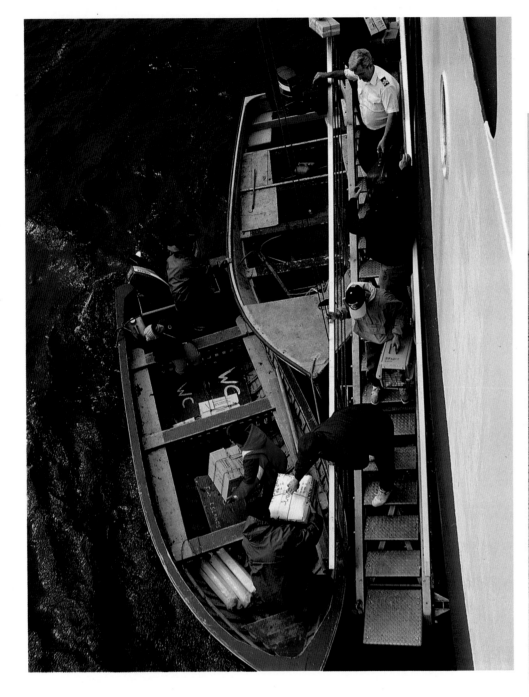

Packages and passengers are transfered for the return trip to Punch Bowl.

Passengers oversee the unloading of provisions at Emily's Harbour, one of dozens of summer fishing stations along the Labrador coast.

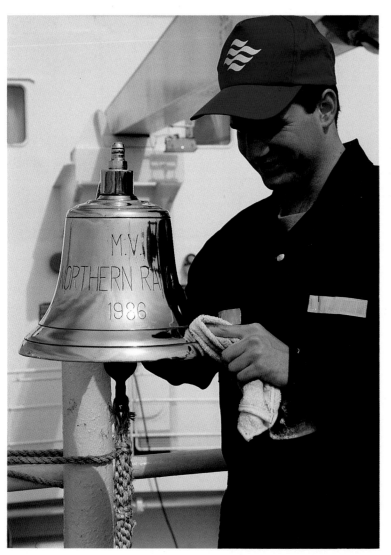

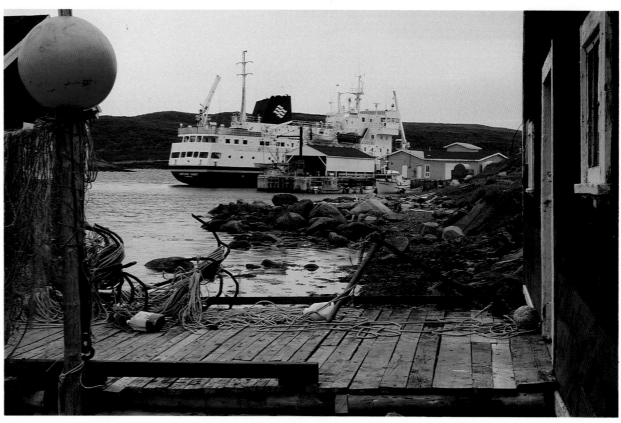

The Northern Ranger at dock in Red Bay, where Basque whalers
were plying their trade more than four hundred years ago.

Cadet Paul Burton performs a daily ritual of life at sea,
the polishing of the ship's bell.

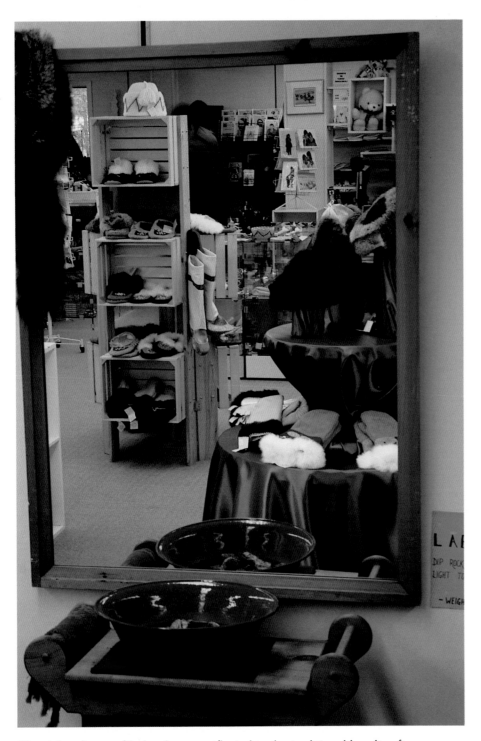

The rich cultures of Labrador are reflected in the traditional handicrafts of her people. (*Labrador Handicraft Gift Shop, Goose Bay*)

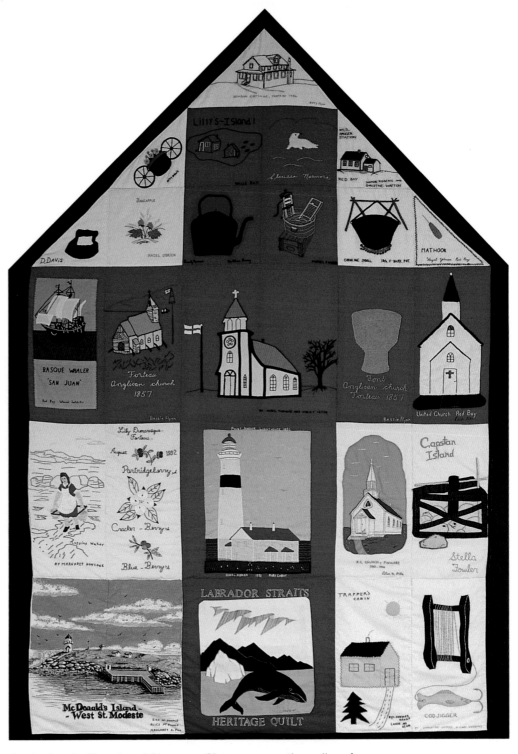

St. Andrew's Church at L'Anse-au-Clair serves as the gallery for an exhibition of the Labrador Straits Heritage Quilt.

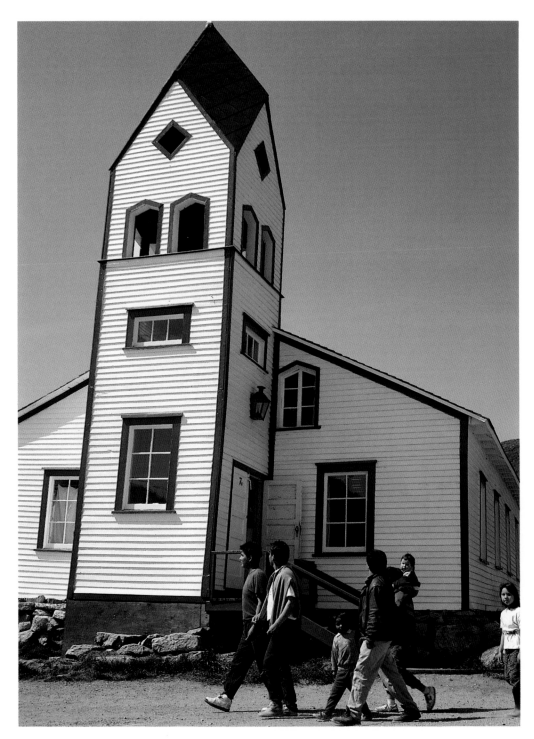

Along with their faith, Moravian missionaries brought a unique architecture from Germany, establishing their Mission at Nain in 1771.

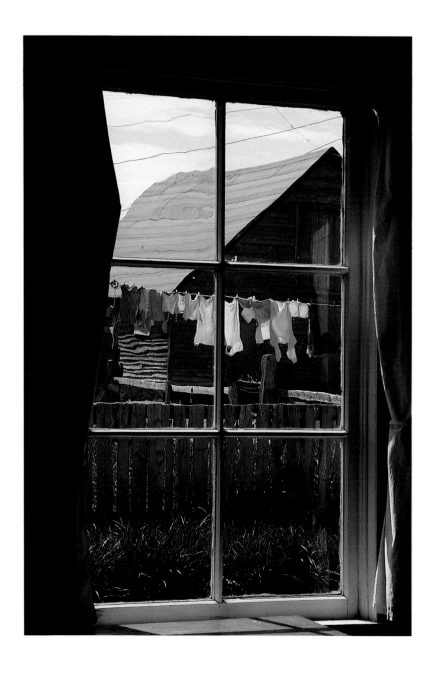

In Nain the season is short for drying clothes that won't freeze solid on the line.

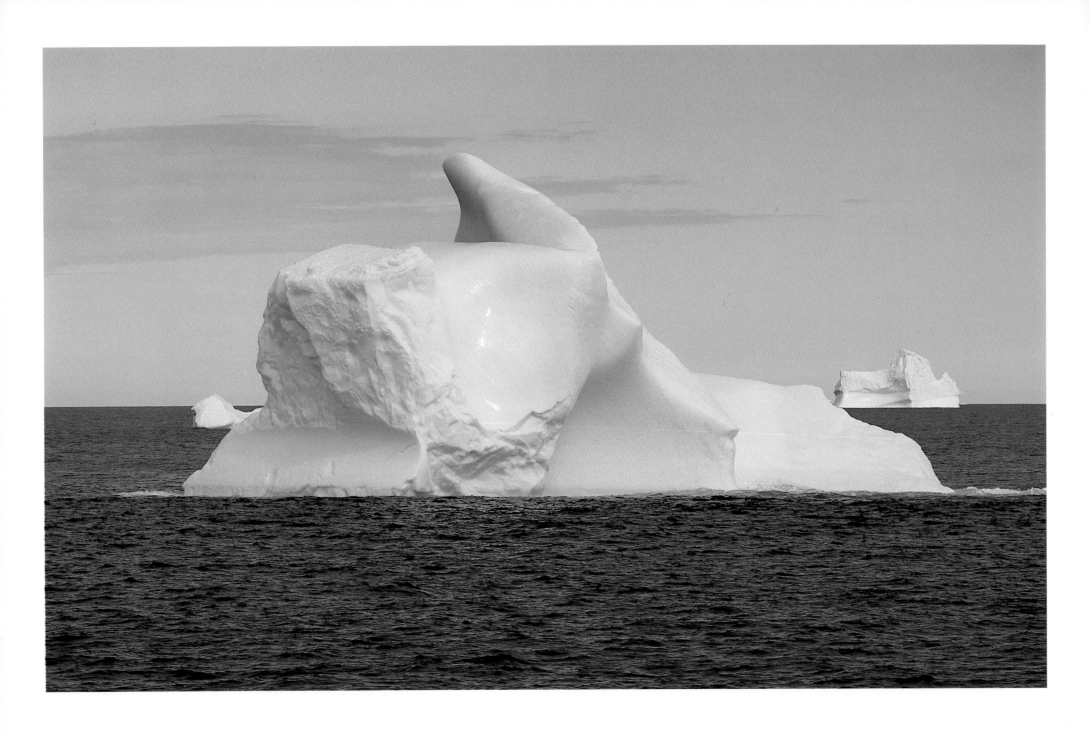

A trio of icebergs near Makkovik, just north of the Adlavik Islands.

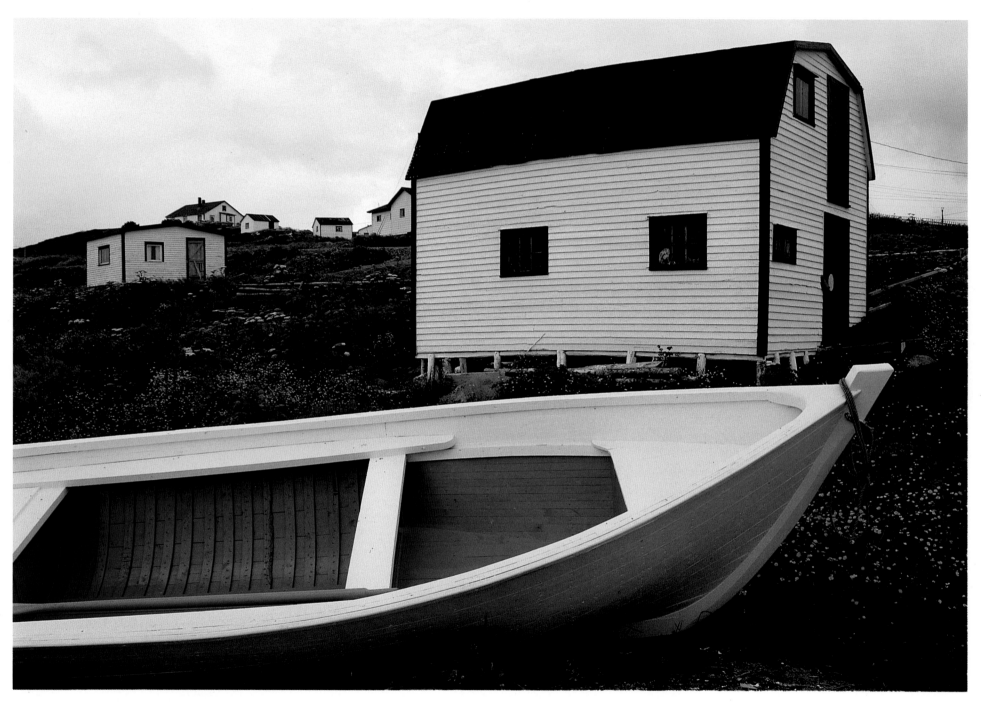

*"The ancient spirit is not dead;
Old times, thought I, are breathing there;
 Proud was I that my country bred
Such strength, a dignity so fair. . ."*

– William Wordsworth, 1802

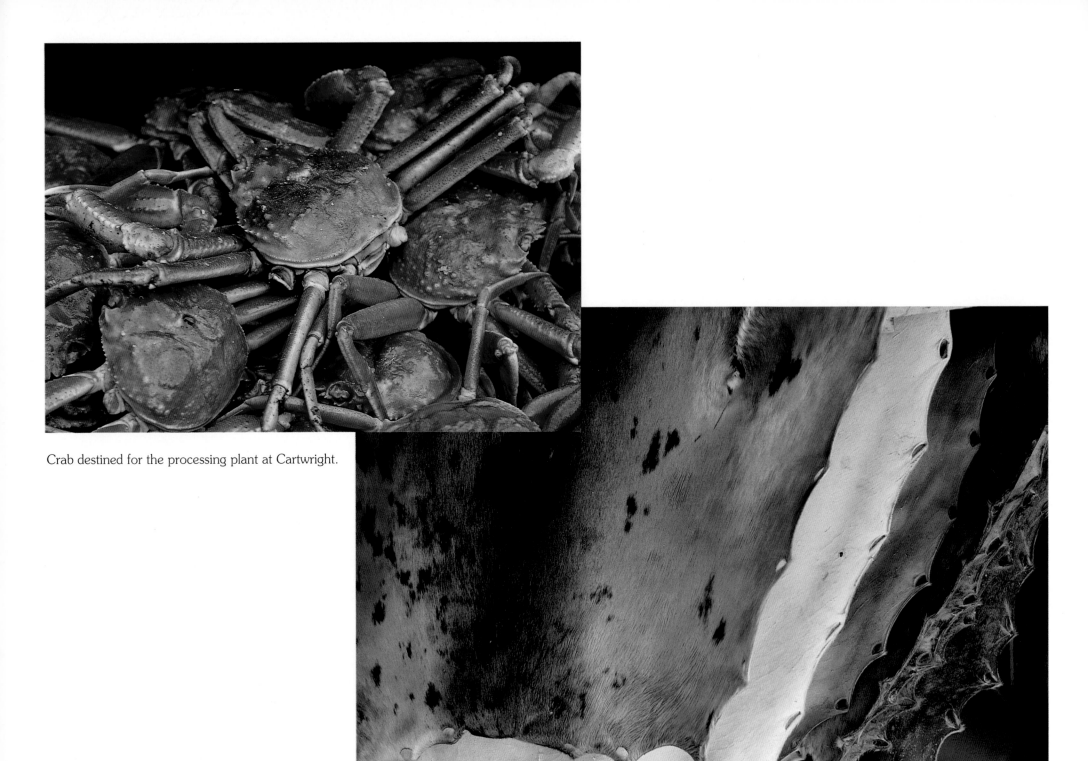

Crab destined for the processing plant at Cartwright.

Sealskin pelts hanging in Ches Flowers' store at Hopedale.

*". . . he turned her young head,
When he gallantly said,
You're a trim little rodney
My hearty."*

– Johnny Burke, 1900

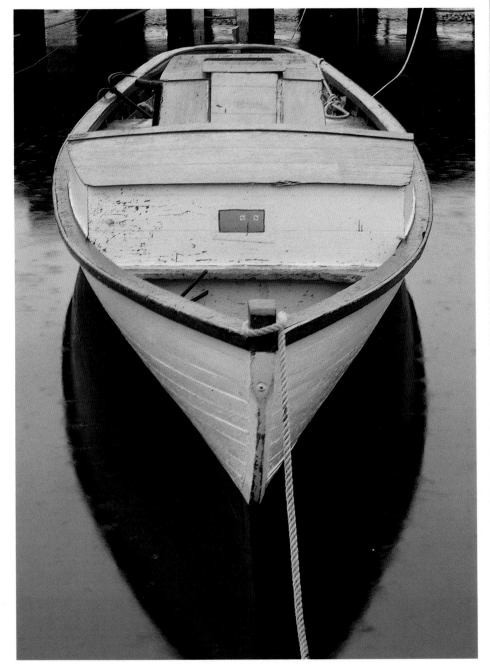

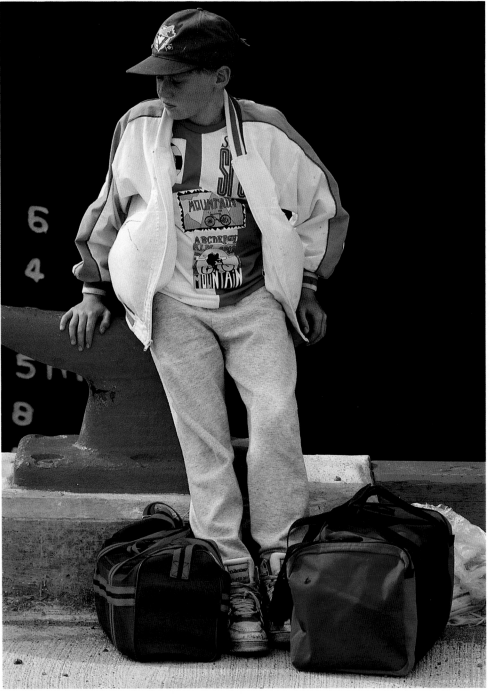

A young passenger contemplates the voyage ahead of him.

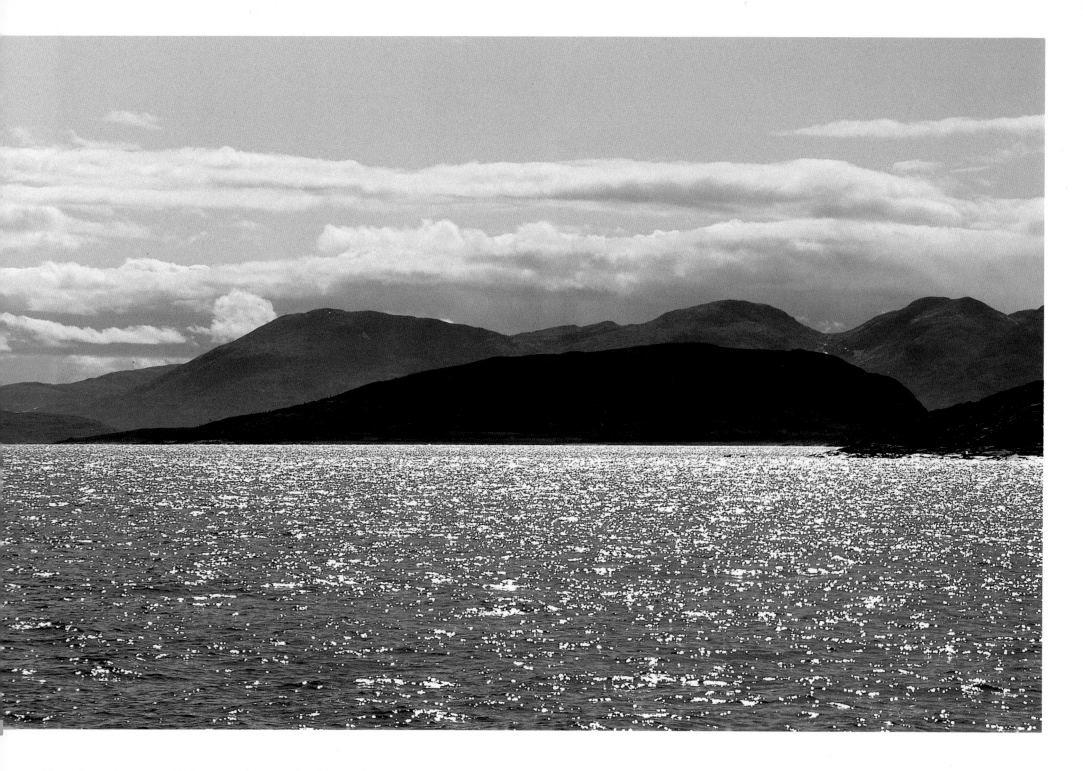

Mount Benedict, rising 829 metres above sea level, near Cape Harrison.

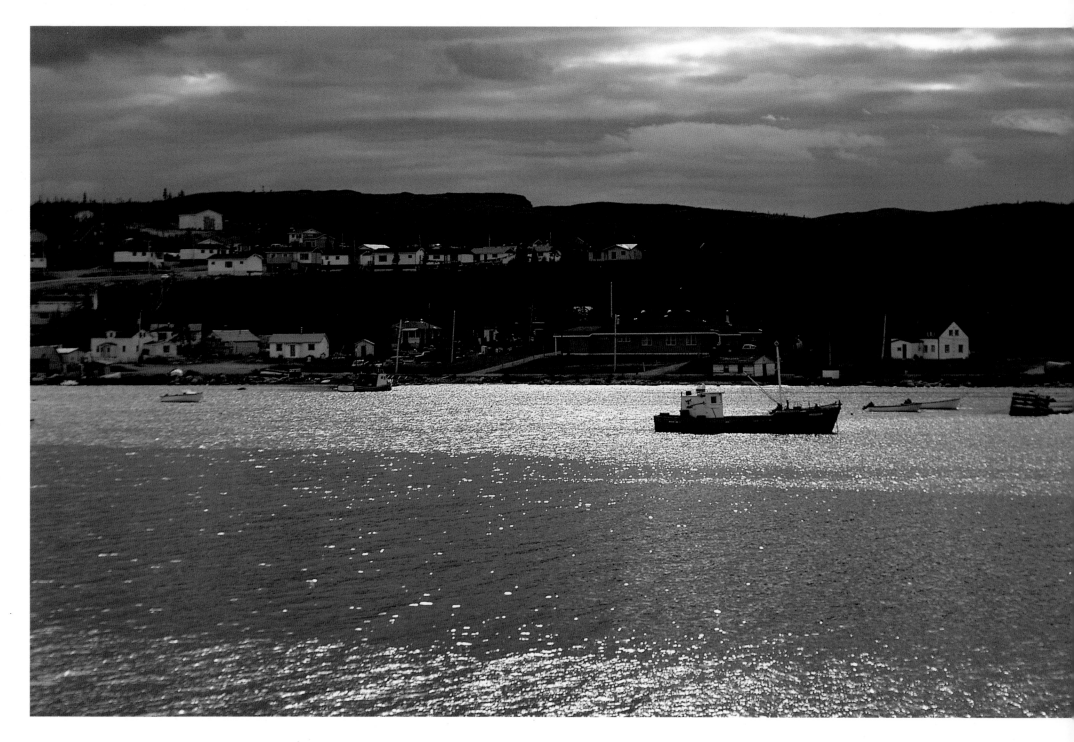

The town of Makkovik was settled in the early 19th century by
Torsten Andersen of Norway and his Labrador wife, Mary Thomas.

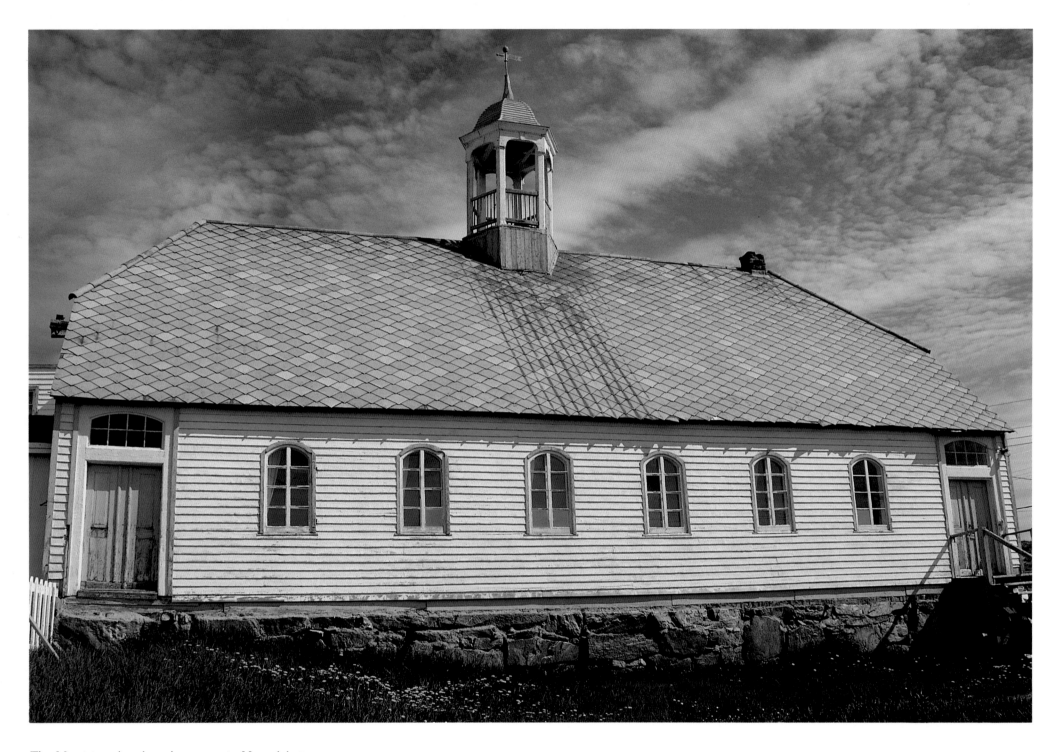

The Moravian church and museum in Hopedale is
the oldest wooden frame building east of Quebec.

A molasses crock and other artefacts in the Hopedale
Museum. The structure has been designated as a National
Historic Site.

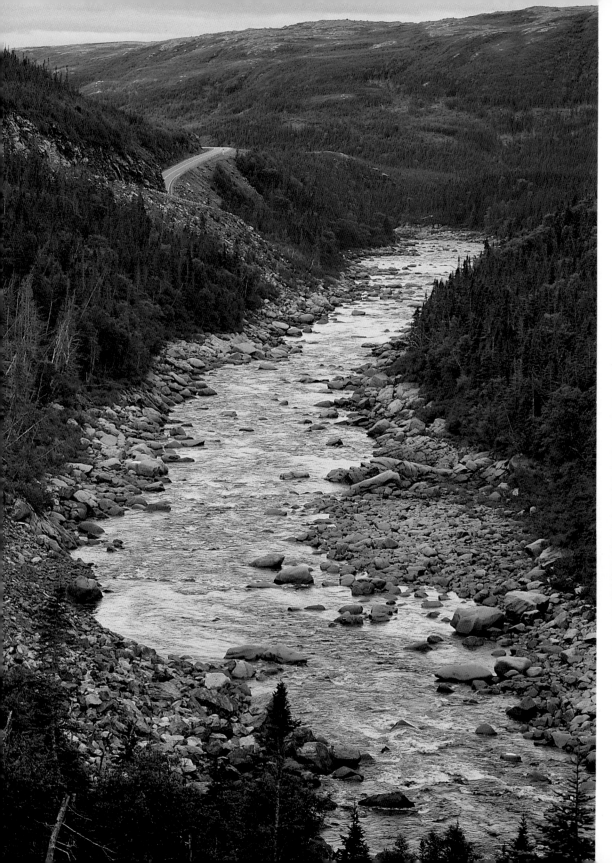

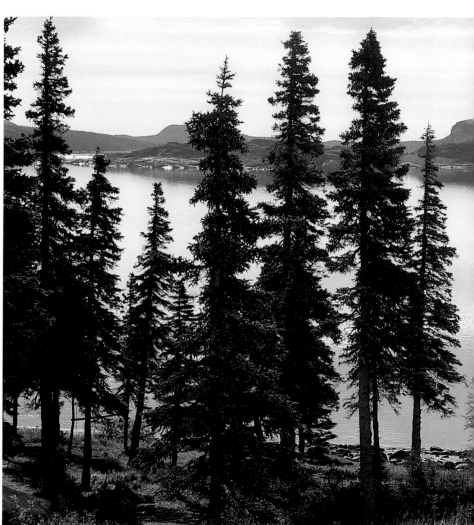

The coastal mountains as seen from the island community of Davis Inlet.

The beautiful Pinware River, famed for its salmon
and trout, flows into the Strait of Belle Isle.

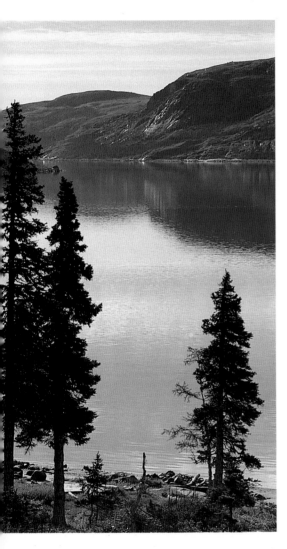
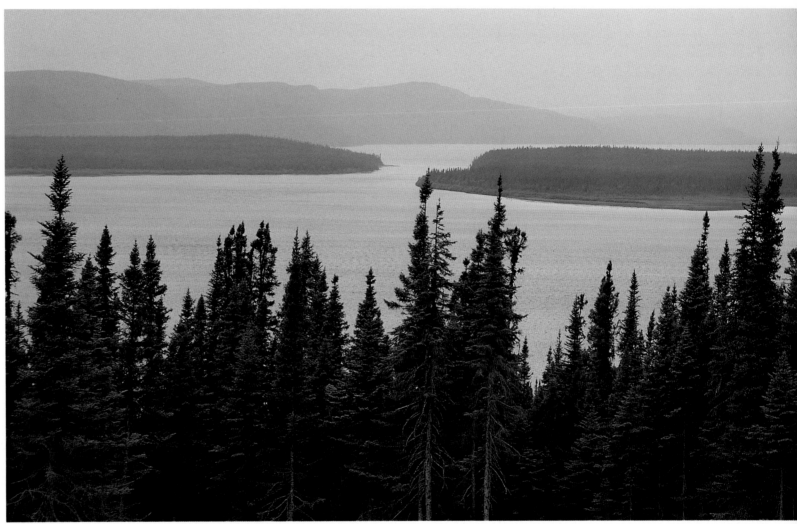

The view from the North West River includes Little Lake in the foreground and Grand Lake in the background, connected by the Rapids.

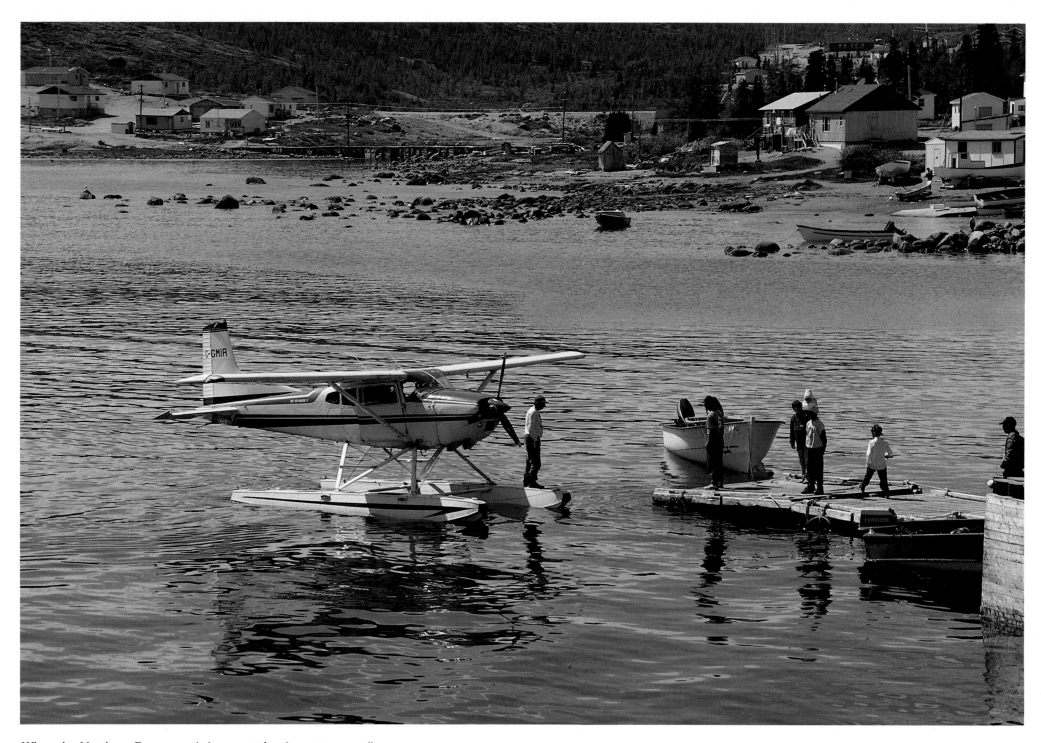

When the Northern Ranger ends her route for the winter, small
aircraft like this one provide Nain's only lifeline to the outside world.

100

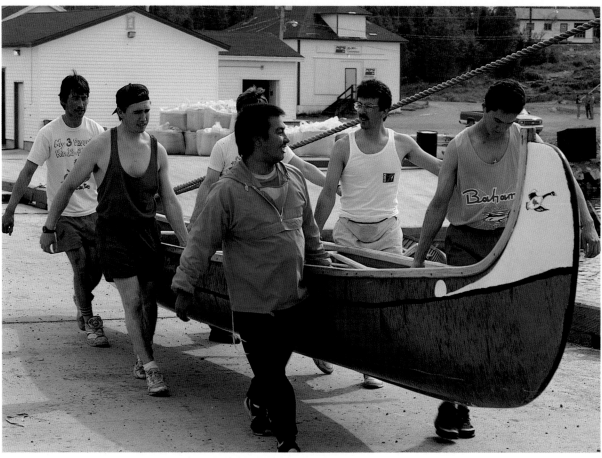

The Rigolet rowing team loads a canoe onto the Northern Ranger for the trip to Goose Bay and the annual Labrador Regatta.

The arrival of the coastal boat causes an outbreak of smiles in Rigolet.

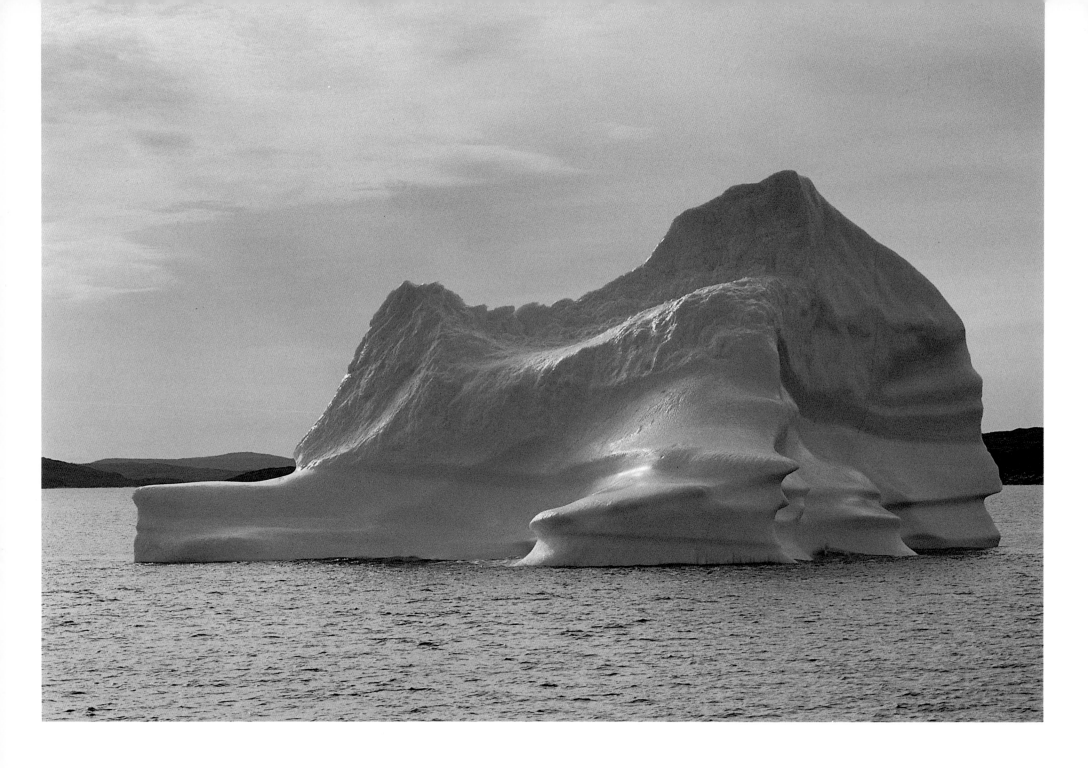

An iceberg grounded in shallow water off the coast.

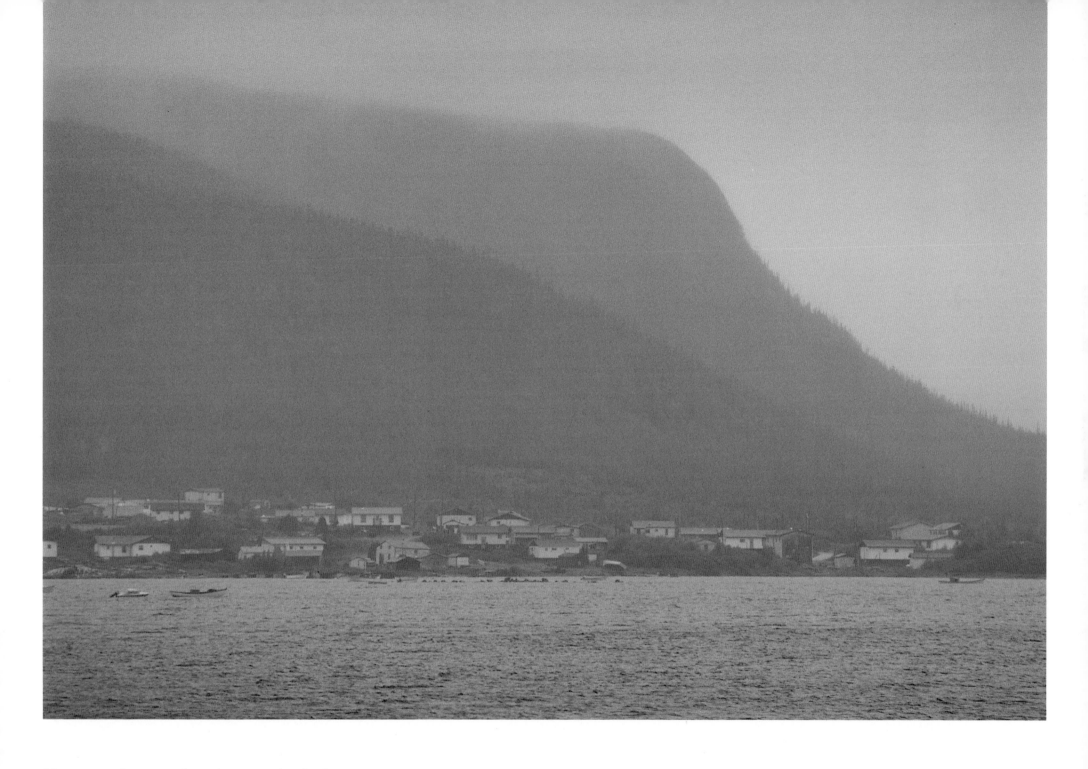

Mountains as large as icebergs loom into the cloud,
dwarfing the town of Port Hope Simpson.

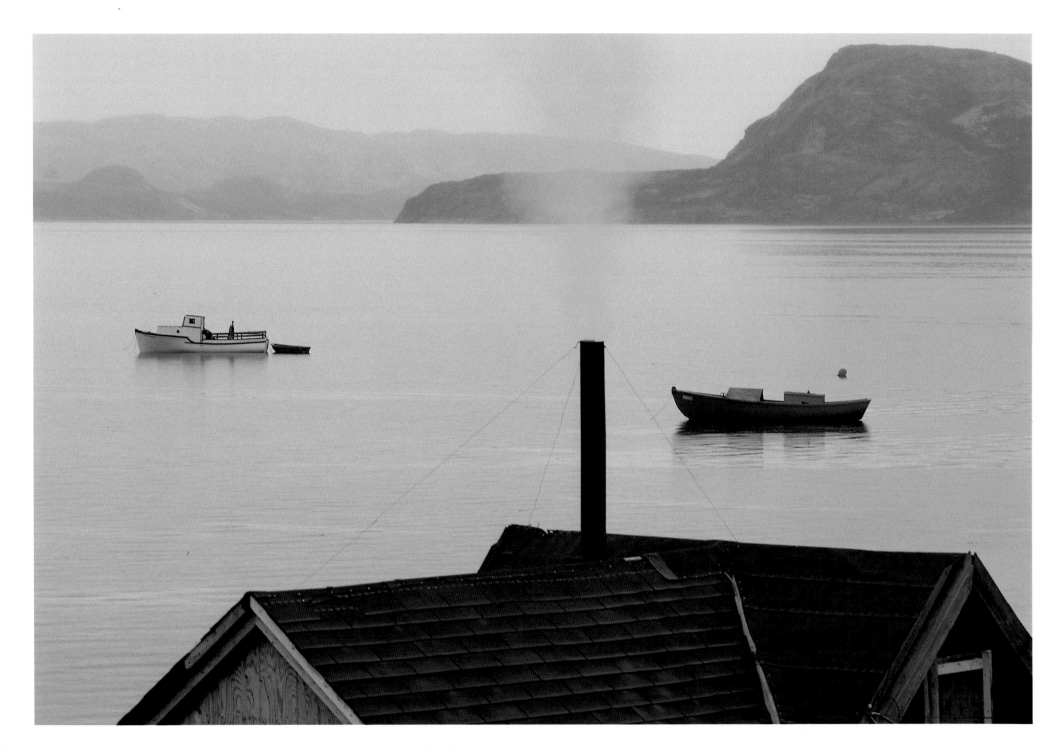

A quiet morning in Nain, a mainly
Inuit community of just over 1000 people.

At 33 metres in height the Point Amour Lighthouse is the second tallest in Canada. ➡
Constructed entirely of limestone, it was completed in 1857.

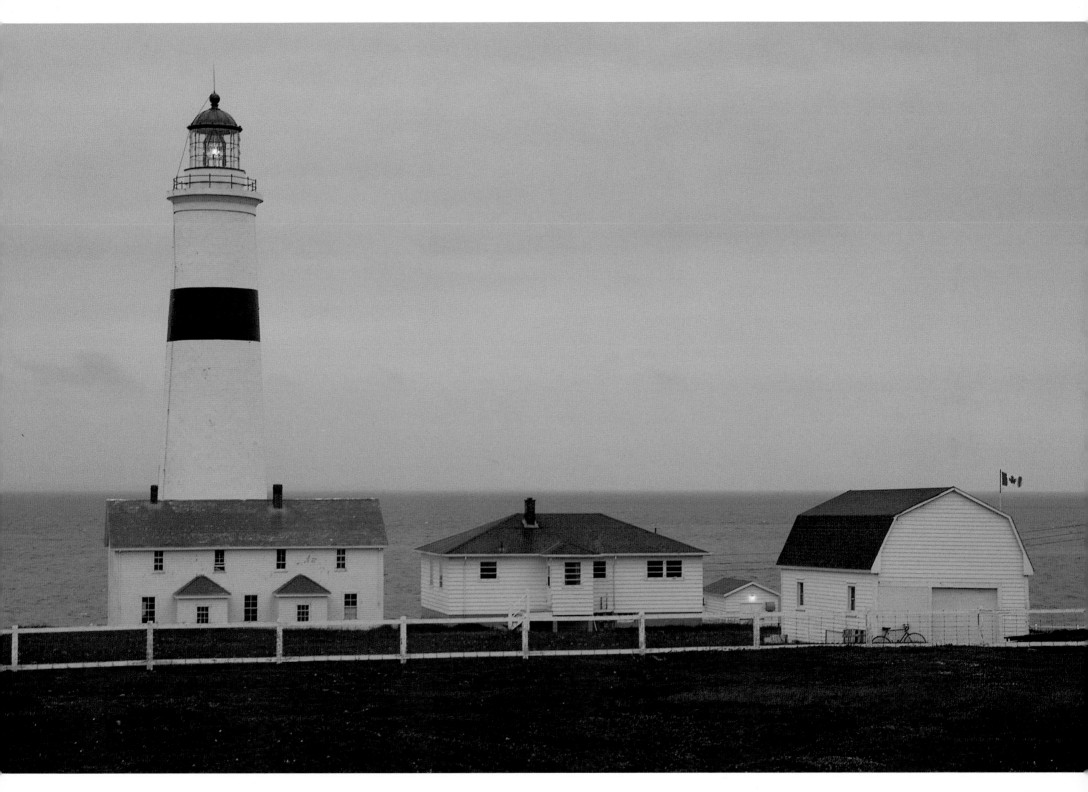

© Copyright 1994 **Ben Hansen M.P.A.**
Printed and bound in China
by Everbest Printing Co. Ltd.

Kodachrome film and Nikon camera
were used to photograph the images.

Canadian Cataloguing in Publication Data
Hansen, Ben, 1927–
St. John's Newfoundland

ISBN 0-9693174-2-5

1. Newfoundland and Labrador
1. Description and Travel Views